50 GEMS OF
Leicestershire
& Rutland

T0294217

MICHAEL SMITH

AMBERLEY

First published 2021

Amberley Publishing
The Hill, Stroud
Gloucestershire, GL5 4EP

www.amberley-books.com

British Library Cataloguing in Publication Data.
A catalogue record for this book is available from the British Library.

ISBN 978 1 4456 9700 0 (paperback)
ISBN 978 1 4456 9701 7 (ebook)

Typesetting by SJmagic DESIGN SERVICES, India.
Printed in Great Britain.

Contents

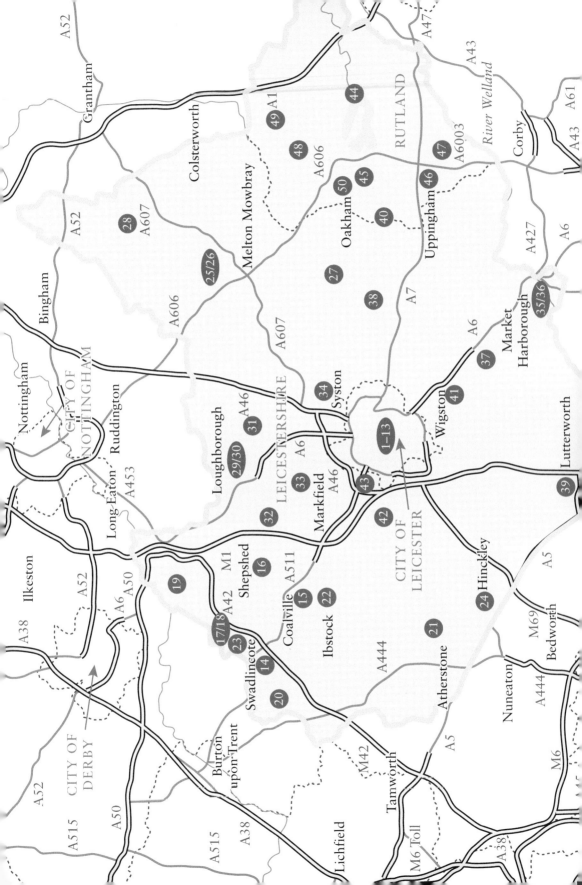

Introduction

Leicestershire is a beautiful and diverse county. Its countryside, market towns and historic buildings attract large numbers of visitors. Rutland is England's smallest county and was for a period incorporated into Leicestershire. Its motto is 'Much in Little'. It has been described as 'a scenic slice of middle England bursting with things to see and do'.

The combined area is full of gems and choosing just fifty has been difficult. I hope that those I have selected will help the reader to appreciate the history and heritage of the area as well as suggest some interesting places to visit. The history of the area dates back to prehistoric times. There are hill forts at Beacon Hill and Burrough Hill and both present stunning views from their ramparts. The Romans established the town of Ratae Corieltauvorum at what is now modern Leicester. The Jewry Wall was originally part of a Roman baths complex.

The castles at Kirby Muxloe and Ashby de la Zouch stand as romantic ruins and a reminder of the power and influence of their builder, William Lord Hastings. St Helen's Church at Ashby de la Zouch was also built by Hastings and has some interesting features including a unique finger pillory. The church of St Peter at Tilton on the Hill is famous for its gargoyles and grotesques.

The discovery of the remains of King Richard III has brought thousands of visitors to the area. His story is vividly told in three of the 'gems' featured in the book. The Reformation resulted in the closure of Leicestershire's monasteries. Many were demolished but at Lyddington the former palace of the Bishops of Lincoln became an almshouse.

Much also remains of the area's industrial past. The Wigston Framework Knitters Museum tells the story of the hosiery industry. In North West Leicestershire, coal mining and, to a much lesser extent, the production of iron made an important contribution to the local economy. The furnace site at Moira has been transformed into a museum and country park. The Charnwood Museum at Loughborough tells the story of more recent industries including the manufacture of light aircraft and of course the production of the famous Ladybird Books.

Leicestershire is also famous for its food and drink. Stilton cheese and Melton Mowbray pork pies are enjoyed by locals and visitors alike and at Mount St Bernard Abbey the monks produce the only genuine trappist beer in the country. The area is not without its quirkiness. Unusual buildings include the Loughborough Carillon, a school on stilts at Market Harborough and a replica of the Statue of Liberty in Leicester.

The gems described in this book are very much a personal selection but I hope you will enjoy exploring two of the most interesting and beautiful counties in the country.

Michael Smith
2020

The City of Leicester

1. Leicester Castle

The castle at Leicester was one of a number raised to subdue the population following the Norman invasion. A typical early Noman castle, it comprised an earthen mound surmounted by a wooden tower or keep. This was encompassed within an enclosed courtyard or bailey surrounded by a ditch and timber palisade. Within the bailey were a number of ancillary buildings including stables, barns, a hall and possibly a chapel. In 1107 Robert de Beaumont, 1st Earl of Leicester, is believed to have rebuilt the timber fortifications in stone. Less than half a century later his son, known as Robert the hunchback, the 2nd Earl, built the Great Hall. This was a substantial stone, aisled building which still survives, though in a much altered form. As the years passed the castle was further extended. Documents from the fourteenth century refer

The Great Hall, Leicester Castle.

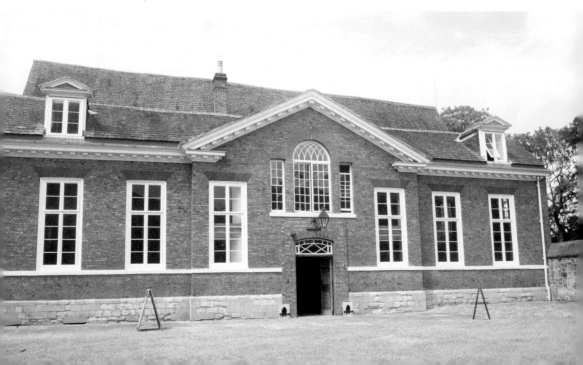

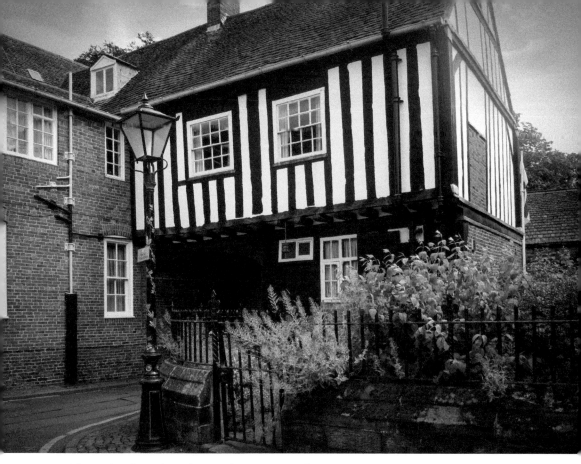

The timber-framed gatehouse of Leicester Castle.

to a number of buildings including a dancing chamber. There was also a herb garden and a watermill in what is now the Castle Gardens. Further work was undertaken in the early years of the fifteenth century with the construction of the Turret Gateway dividing the castle from the Newarke and the remodelling of the kitchen block to the south of the Great Hall. A few decades later a fire caused some damage which resulted in the rebuilding of the Castle Gateway as a timber-framed structure with an adjoining two-storey range of apartments. Leicester Castle played an important role in the history of the city and the nation. The parliament of England was held here in 1426 and it was for many years a royal residence. It was visited by a number of monarchs throughout the fourteenth and fifteenth centuries. The last to do so was the ill-fated Richard III who came here twice in 1483, signing letters from 'my castle at Leicester'. The castle continued to play an important role after this period. Assizes and quarter sessions were held here for many years and in the nineteenth century the Great Hall was remodelled to create a cell block, and later courtrooms with a jury room, judges' rooms and a viewing gallery. Today the original castle mound is clearly visible and the Turret Gateway and the timber-framed gatehouse are easy to find. The Great Hall is now part of De Montfort University and is open to visitors during the last Sunday of the month.

For more information and maps go to: visitleicester.info/whats-on/heritage-sundays. The best starting point to explore what remains of the castle is at the front of the Great Hall on Castle View LE1 5WH.

2. Trinity Hospital

Trinity Hospital is a little-known gem hidden away in the historic heart of Leicester, close to the castle. Known initially as the Hospital of the Honour of God and the Glorious Virgin and All Saints, it was founded in 1331 by Henry Plantagenet, the 3rd Earl of Leicester and Lancaster. He was a powerful and wealthy man; a grandson of Henry III and principal advisor to Edward III. The hospital was originally built to support fifty poor men and women, twenty of whom were permanently resident. They were cared for by a warden, four chaplains and five attendants. The original building was a long single-storied hall divided by an arched aisle with a chapel at the end. This design enabled the patients to take part in the services without leaving their beds. Behind the hospital was a garden which grew medicinal herbs for the patients. In 1614 King James I granted a new charter and gave the institution the name of the Hospital of the Holy Trinity.

The hospital underwent a number of changes over the years. Towards the end of the eighteenth century, the now crumbling medieval structure was rebuilt creating a two-storey building with rooms for staff, kitchens, washrooms and a sitting room. Further changes to the hospital took place at the start of the twentieth century when road building resulted in the demolition of one end of the hospital. It was rebuilt at an angle, a feature still apparent today. In 1994 the hospital was acquired by De Montfort University, who moved the staff and patients to new accommodation just a short distance away. Little remains of the original structure apart from the fourteenth-century chapel and a small part of the entrance hall. The chapel contains the tomb of Lady Mary Hervey, who was governess to the children of Henry IV and a generous patron of the hospital.

The hospital is on the Newarke. It is open on the last Sunday of the month between April and November. For more information and maps go to: visitleicester.info/whats-on/heritage-sundays.

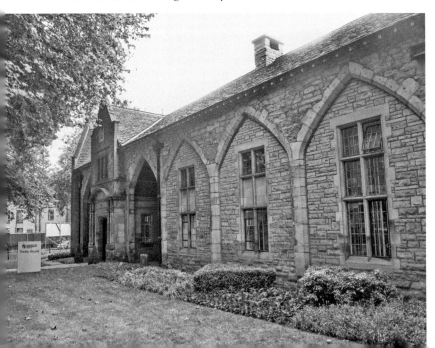

Trinity
Hospital,
Leicester.

3. The Guildhall

Leicester Guildhall is one of the oldest and best-preserved timber-framed halls in the country. Dating from 1390, it was built by the Guild of Corpus Christi, a group of wealthy and powerful merchants who exercised considerable influence on the life of the town. The Guildhall also provided a home for the priest, who was employed to pray for the souls of guild members at the nearby St Martin's Church (now the cathedral). The guild prospered and towards the end of the fifteenth century the Guildhall was extended. Wings were built at either end of the original hall creating a U-shaped building set around a small central courtyard. Many of the original guild members were influential in the business of the town and from 1485 the Corporation (the forerunner of the City Council) began to hold their meetings in the Guildhall. Over the centuries the building played an important part in the civic and social life of Leicester. The quarter sessions were held here and it was also used for public meetings, civic dinners and theatrical performances. In common with similar bodies, the Guild of Corpus Christi was abolished during the Reformation and the Corporation seized the opportunity to purchase the Guildhall for the sum of £25. 5s. 4d.

In the early seventeenth century the ground floor of the west wing was converted into the Mayor's Parlour, above which was a jury room which was used when the courts were in session. In 1632 the town's library was moved from St Martin's

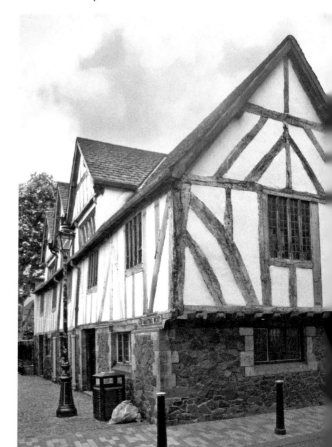

Leicester Guildhall.

Church into the east wing of the Guildhall. It is one of the oldest libraries in the country and still holds a considerable number of old books and manuscripts. By the nineteenth century the Guildhall could no longer deal with the increased scope of local government and a new town hall was built in 1876. After this time the Guildhall was used for a number of functions including as a school and a police station. By the early years of the twentieth century the building had fallen into disrepair but was restored and reopened as a museum in 1926. Today the building serves as a museum and a performance venue which hosts regular touring productions.

Leicester Guildhall is open every day of the week and is free to enter. It is located on Guildhall Lane LE1 5FQ and is close to the cathedral.

4. The Jewry Wall and Roman Leicester

The Jewry Wall is a section of wall from a Roman bath-house standing in the middle of modern Leicester. It was constructed around the middle of the second century as part of the Roman town of Ratae Corieltauvorum and is one of the tallest surviving pieces of Roman masonry in the country. The bath-house was a substantial building and many of its foundations still survive. These indicate that the baths covered a considerable area and included hot and cold rooms and a sauna, as well as changing rooms and an exercise area.

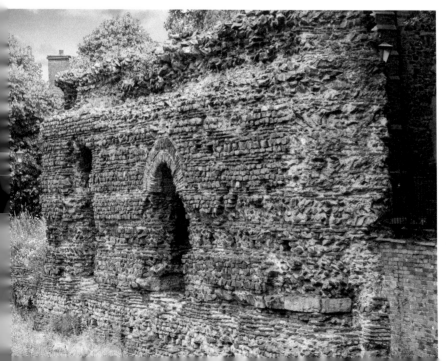

Jewry Wall, part of a Roman baths complex.

Elsewhere in the city archaeologists have discovered a great deal about Roman Leicester. Evidence suggests that by the third century AD this was a thriving administrative and commercial centre. At the heart of the town was the forum and basilica which served not only as a marketplace but also as a focus for a wide range of social, political and religious activities. The area surrounding the forum contained a number of private and public buildings including the public baths, a temple dedicated to the god Mithras and a market hall. The remains of a number of houses have also been discovered. A courtyard house on what is now Vine Street contained at least twenty-six rooms. Some of these had wall paintings and underfloor heating! As one of the principal towns of Roman Britain, Leicester has an important place in the early history of this country. It is well worth pausing at the Jewry Wall when visiting other 'gems' in the city centre.

The Jewry Wall is on St Nicholas Circle LE1 4LB. At the time of writing the Jewry Wall Museum is closed but there are plans for it to be improved and reopened at some point in the next few years.

5. Abbey Park

Abbey Park can trace its history back to the foundation of Leicester Abbey in 1138. The Abbey of St Mary de Pratis, as it was known, became one of the wealthiest and most important abbeys in medieval England, with lands and property across Leicester and beyond. Cardinal Wolsey came here in 1530 on his way to London to answer charges of high treason. He got no further than Leicester, for he was taken ill and died here. He was buried in the abbey church. Only a few years later King Henry VIII closed all the monasteries and seized their lands and property for his own benefit. Leicester Abbey was soon demolished and some of the stone was used to build a mansion on part of the site. This became known as Cavendish House after it was acquired by the 1st Earl of Devonshire in 1613. The city council purchased Abbey Park from the Earl of Dysart in 1876 and plans were made for a much-needed open space close to the heart of the city. A competition to choose a design for the new park was won by William Barron who created many of the features which are still evident today. The abbey lands did not originally form part of the park but were donated to the city by the Earl of Dysart in 1925.

Today the park covers an area of 89 acres divided by the River Soar. To the east of the river lies the highly decorative Victorian part of the park with its evergreen shrubberies, trees, boating lake, miniature railway and formally planted flower displays. On the western side of the river are the remains of the abbey and ruins of Cavendish House. This area of the park also contains a café, play area and pets' corner. A statue of Cardinal Wolsey stands outside the café. The park attracts thousands of visitors each year and hosts a number of events including an annual firework display, sporting activities and the Hindu colour-throwing Holi festival.

Abbey Park is located on Abbey Park Road Leicester LE4 5AQ. There are car parks at Abbey Park Road and St Margaret's Way.

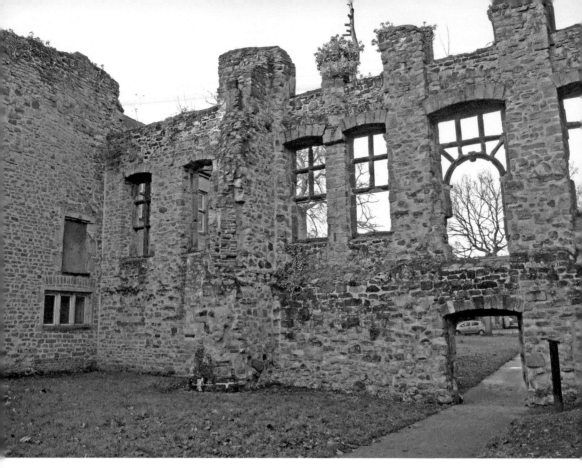

Above: The ruins of Cavendish House in Abbey Park, Leicester.

Left: Statue of Cardinal Wolsey outside the café in Abbey Park.

6. Leicester Cathedral

The Normans began the construction of what was then St Martin's Church sometime around 1086 although only fragments remain of this original structure. It was extended and partially rebuilt during the Middle Ages when the arcades were added and the nave extended. The Reformation also had an impact on the interior of the church when statues, screens and stained glass were swept away. Other changes took place during the Victorian period. It was at this time that the tower was rebuilt and the spire added. A new west window was constructed and the nave roof completely rebuilt to accommodate it. Throughout its history the church maintained strong links with the local community and it came as no surprise that when the Diocese of Leicester was re-established in 1927 the church was chosen to become the new cathedral. The cathedral contains a number of interesting features. The Vaughan Porch on the south side of the cathedral depicts seven figures who all have links with the city. The magnificent hammer-beam roof in the nave dates from the medieval

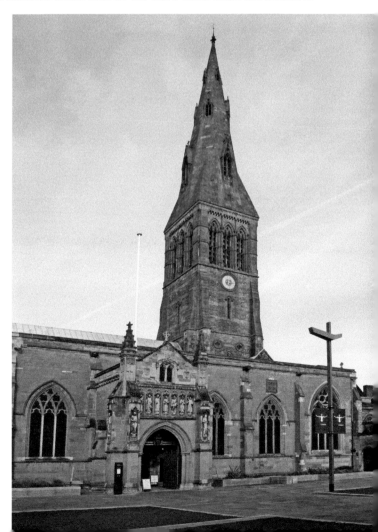

Leicester Cathedral.

period although it has been restored several times over the centuries. The Bishop's Chair can also be seen here. In the south aisle three of the 'figures of repose' date from the fourteenth century. These all depict people with some sort of medical problem and were designed to inspire and focus the thoughts of those who came here in the Middle Ages to pray to Saint Martin in the hope of recovery.

Today the cathedral is most famous as the last resting place of King Richard III. The remains of the king were discovered nearby in 2012 and on 26 March 2015 he was finally laid to rest with all the pomp and ceremony due to a king of England. The tomb was carved from Swaledale limestone and inscribed with a simple cross. It stands on a marble plinth. This is inscribed with the king's name and motto, the dates upon which he was born and died and his coat of arms. Also displayed is the pall or cover for the king's coffin. On one side are embroidered medieval figures including King Richard's wife, Anne, and his only child, Edward. The other side depicts some of the people who found, examined and reburied his body. The connection with Richard III continues in the cathedral grounds where a statue of the king stands with his crown in one hand and his sword in the other.

Leicester Cathedral is in the centre of the historic part of the city on Peacock Lane LE1 5FQ.

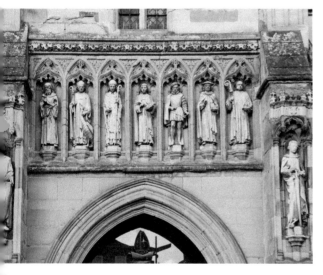

The Vaughan Porch, Leicester Cathedral.

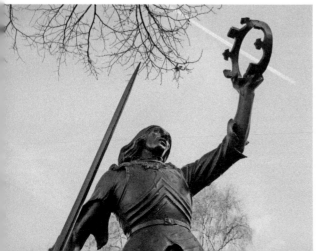

Statue of Richard III in the grounds of Leicester Cathedral.

7. King Richard III Visitor Centre

The world's media organisations descended on Leicester in 2012 when the remains of King Richard III were discovered beneath a car park in the centre of the city. Nicknamed the 'King in the Car Park', the discovery generated an enormous interest in the story of England's most controversial monarch. The King Richard III Visitor Centre was created in response to that interest. Standing close to where the remains were found, the visitor centre explores the life of the king through the themes of Dynasty, Death and Discovery. Dynasty explores the life and times of the king, the background of the Wars of the Roses, his achievements as king and his possible involvement in the murder of his nephews, the famous 'Princes in the Tower'. The death of the king is vividly described through a variety of exhibits including a film which ends with Richard's cavalry charge and his last moments. Unhorsed and surrounded he fought on bravely until he was at last cut down, immortalised as the last English king to die on the battlefield! On the first floor, Discovery describes the latest techniques of scientific analysis which were used to identify and understand the remains.

One of the most interesting exhibits is a replica of the king's skeleton. An analysis of the original showed that he suffered from severe scoliosis. It also revealed eleven

The Throne Room, King Richard III Visitor Centre. (Image provided by the King Richard III Visitor Centre)

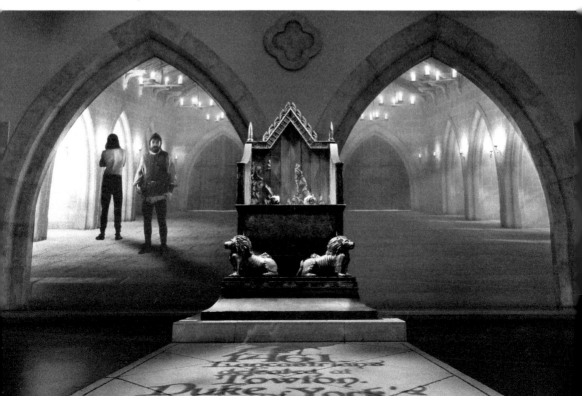

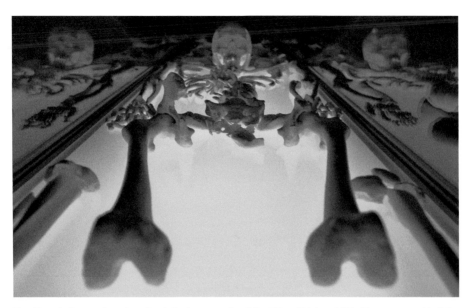

Replica skeleton showing the injuries sustained by King Richard III. (Image provided by the King Richard III Visitor Centre)

injuries, with the vast majority to the face and head. The latest facial reconstruction techniques have also been used to show the visitor what the king would have looked like in life. On the same floor another display explores the fate of Richard's reputation through the writings of Shakespeare and others. The most stunning exhibit in this section is the 'fascist' uniform worn by Sir Ian McKellan in his 1995 portrayal of Richard III. For those wishing to refresh themselves after their visit, the Blue Boar Café in the visitor centre is named after the inn where King Richard III reputedly spent the night before the battle.

The King Richard III Visitor Centre is just a few hundred yards from the cathedral and a visit to them both can easily be combined in an afternoon.

8. New Walk: A Georgian Promenade and a Victorian Museum

New Walk was originally known as Queen's Walk (in honour of King George II's wife, Charlotte) and was for many years regarded as one of the most elegant features of Georgian Leicester. Even today it is something of an oasis of calm in a

busy city. It was created in 1785 and was initially a 20-foot-wide gravel promenade that stretched from the city centre to the racecourse, which was replaced by Victoria Park in 1882. The expense of constructing the walk was borne partly by the Corporation, who paid for the labour and allowed gravel to be dug from Corporation pits, and partly by a public subscription of £250, which paid for the trees and shrubs. The first houses on New Walk were built in the 1820s and were designed as elegant residences for people of independent means as well as members of the business and professional classes. The development of the area was strictly controlled to preserve its character and protect the public's enjoyment of the promenade. Houses had to be at least 10 yards from the Walk and fenced off by iron railings. To further protect its function as a polite walkway, carriages were not allowed access. New Walk continued to be popular with the well-to-do and up-and-coming members of society and more houses were built here in the Victorian era. It was described in 1847 as 'the only solely respectable street in Leicester'! The nature of the area has changed over the years and today most of the properties are offices. It was designated as a conservation area in 1969 and remains a discrete 'gem' of which the city is justifiably proud.

The New Walk Museum was built in 1836 as a nonconformist school. When this closed just ten years later the building was purchased by the Corporation. With the encouragement and support of the Leicester Literary and Philosophical Society the Town Museum, as it was then known, opened its doors to the public on

New Walk and the Georgian Terrace.

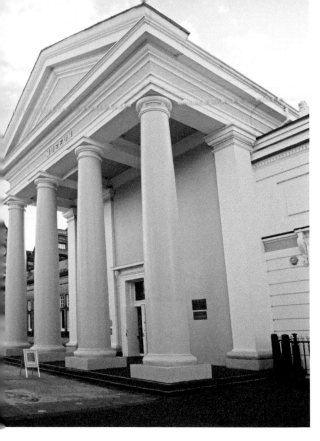

New Walk Museum.

21 June 1849. It is today Leicester's principal museum. Galleries now host exhibits on themes such as Ancient Egypt, Dinosaurs and the Arts and Crafts movement.

The New Walk Museum (LE1 7EA) is easily accessed via a stroll down the pedestrianised New Walk from the city centre.

9. The River Soar and the Leicester Riverside Festival

The River Soar is a major tributary of the River Trent and is the county's principal river. In the eighteenth century the Soar was made navigable between Loughborough and the Trent, and then through to Leicester. Until the advent of railway competition, it was an important and profitable commercial waterway which was used to transport a wide range of goods including coal, bricks and lime. The section which flows through the city centre is today a haven for wildlife and an important leisure amenity. It is home to large numbers of water birds and coarse fish as well as healthy populations of the endangered white-clawed crayfish. In recent years otters have also

been observed here. It is a popular route for boats of all types, with narrowboats, river cruisers and various other craft all plying their way along the river. The riverside footpath and cycle routes provide a fascinating way of exploring the many places of interest which lie along the banks of the river. These include Abbey Park, the National Space Centre and the Museum of Technology. There are a number of pubs and cafés along the route which allow visitors to pause for a while to appreciate the peaceful beauty of the area.

A two-day Riverside Festival is held in June each year, which spreads across Bede Park, Straight Mile, Western Boulevard and Castle Gardens. In recent years this has attracted thousands of visitors to sample the many attractions available. These have included live music, a children's fun fair, street food, craft stalls, exhibitions and displays from a variety of organisations. For the more adventurous, boat rides and a chance to take to the water in a canoe are also available.

The Riverside Festival is well publicised in the local press. Details of the programme and parking facilities can be found on the City Council website: (www.leicester.go.uk).

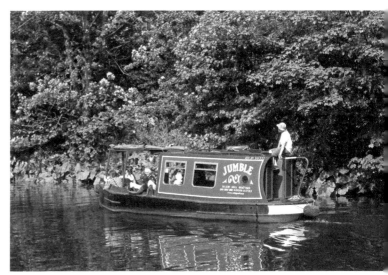

Trip boat at the Leicester Riverside Festival.

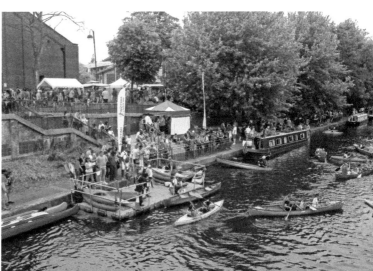

Fun activities taking place at the Leicester Riverside Festival.

10. The Jain Temple

Leicester's Jain Centre was the first Jain Temple to be consecrated in the Western world. Originating in India, the Jain religion dates back thousands of years. Jains believe in equality in all things and vow to renounce violence. They are vegetarians, care for the environment and are tolerant of other faiths. The first followers of Jainism arrived in Leicester from India and Kenya in the early 1970s and soon began looking for a place in which to worship. The Jain Centre began life in 1863 as a congregational chapel, but a shifting population and a decline in attendance resulted in its closure in the 1970s. The building was purchased by the Jain community who set about raising funds to create their own temple. Generous donations came from many parts of the world and the centre was opened in 1988. Today the building is a spectacular architectural gem as well as a place of prayer and quiet contemplation. The exterior is clad in white marble decorated with various symbols of the Jain faith.

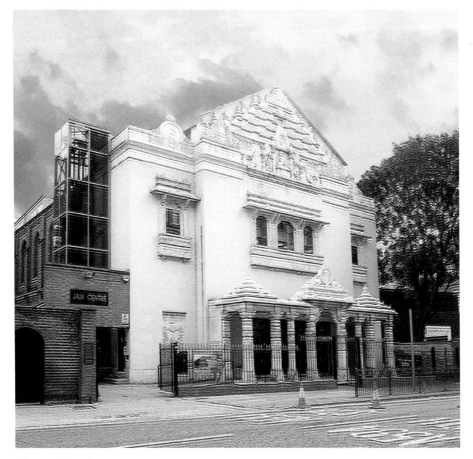

The Jain Temple.

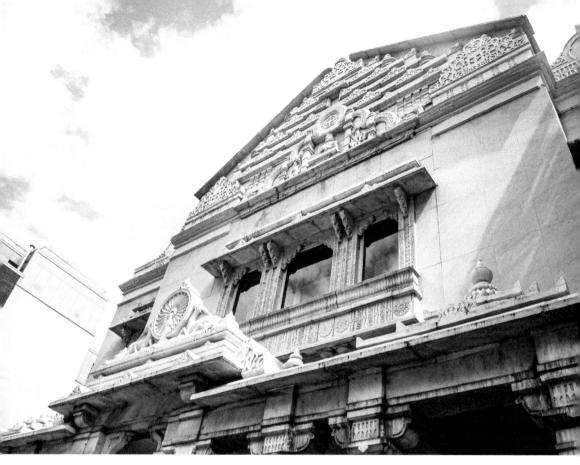

Marble façade of the Jain Temple.

These were carved in India before being shipped to the UK. Interior decorations include forty-four magnificently carved sandstone pillars, a beautiful temple dome and ceiling with traditional carvings, all enhanced by mirrored walls and a white marble floor. Stained-glass windows depict the life of Mahavira, a central figure in the Jain religion. It is claimed that in total it took 254,000 man hours to carve and assemble the temple.

The Jain Centre is located at 32 Oxford street, Leicester LE1 5XU. Please behave respectfully if you visit the temple. Remove your shoes before entering and do not touch any statues or take any photographs.

11. Leicester's Golden Mile

Leicester's Golden Mile has been described as the closest the UK comes to an authentic Indian bazaar and is regarded by many as an essential sight to see on a visit to Leicester. Stretching along the Belgrave Road from its junction with Abbey Park Road to the turn for Loughborough Road, it is home to one of the largest

concentrations of Indian clothes and jewellery shops in the country. The area was originally home to a number of important manufacturing companies including Wolsey and the British United Shoe Machinery Company. The 1960s and 1970s saw a period of economic decline in the area. Many of the local firms went out of business and the houses previously occupied by their employees lay empty. These rows of Victorian terraces provided affordable housing for an influx of migrants from India and Pakistan. Many of the Ugandan Asians facing persecution in their own country also made their homes here.

In the years that followed, these new residents drew upon their skills and their links with the Indian subcontinent to develop a wide range of small businesses which were designed initially to serve the local community. A walk down the Golden Mile is a fascinating way of spending an afternoon. Visitors may gaze in the shop windows to view the latest Indian fashions although children are more likely to have their faces pressed against the windows of the traditional sweet shops. Some of the finest Indian jewellery is available to buy and the area is home to some of the best Indian restaurants in the country.

Belgrave Road is only a short walk from the city centre but there is a car park on MacDonald Road LE4 5HD.

Bollywood-style street art on Leicester's Golden Mile.

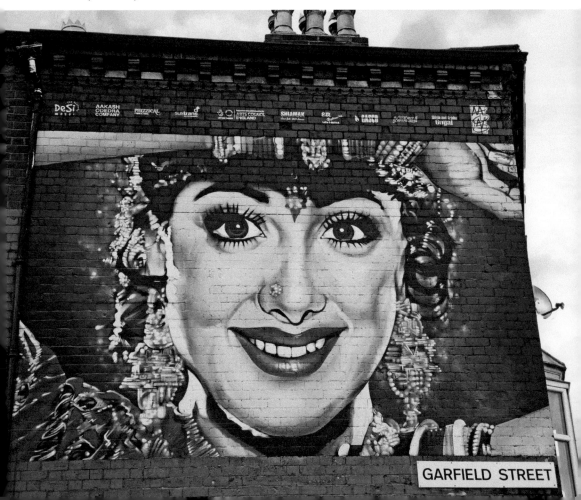

A variety of shops on Belgrave Road.

12. Leicester's Diwali Celebrations

Diwali is an important religious festival which originated in India and is now celebrated by millions of people throughout the world. Although often thought of as a Hindu festival, it is also celebrated by Sikhs and Jains as well as some Buddhists. Hindus celebrate Diwali for different reasons but all have a common thread of celebrating good over evil and light over darkness. During the festival people decorate their homes with lights and oil lamps called diyas. For many people Diwali honours Lakshmi, the Hindu goddess of wealth. The lamps are believed to help Lakshmi find her way into people's homes, bringing prosperity in the year to come. This religious festival is also marked by family gatherings and the exchange of gifts.

Leicester claims to hold the largest Diwali celebrations outside India. In recent years upwards of 40,000 people have gathered in the Belgrave Road area to enjoy vibrant shows of light, music and dancing. Huge crowds cheer as 6,000 lights are switched on to bathe the area with light and colour. Other activities include a parade of giant puppets. The Wheel of Light (a 100-foot illuminated Ferris wheel) dominates

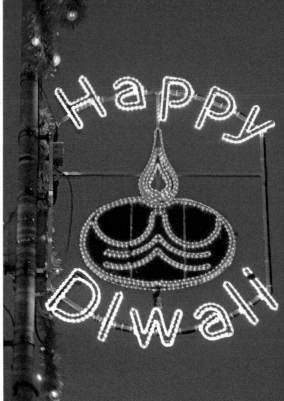

Above left: The Diwali Wheel of Light on Belgrave Road.

Above right: Diwali street lights.

the area and provides an opportunity for people to enjoy views across the city. The evening culminates with a spectacular firework display. This is just the start of two weeks of cultural events which include traditional Indian music and dance, theatre performances, craft activities, cultural talks and exhibitions. The festival ends two weeks later on Diwali Day when another stunning firework display brings an end to an evening of Bollywood dance and music performances. Diwali in Leicester reflects the multicultural nature of the city and is celebrated by tens of thousands of people of all races, colours and creeds.

Details of parking and special bus services are published well in advance by Leicester City Council.

13. Statues and Their Stories

In 2019 the *Leicester Mercury* published an article describing some of Leicester's public works of art and outlining the stories they tell. Some celebrate the lives of individuals or organisations who have contributed to the life of the city or the wider world, whilst others symbolise more general aspects of the past. Some of the

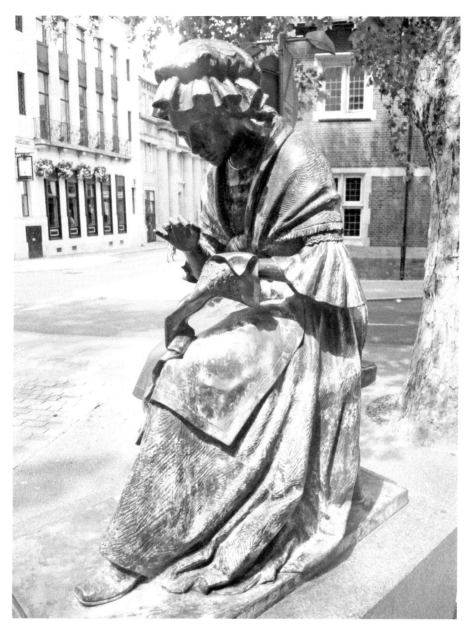

The Seamstress statue.

most interesting include those of Alice Hawkins, Thomas Cook and the famous seamstress. The statue of Alice Hawkins stands in the new Market Square and commemorates the life of this famous suffragette. She joined the Women's Social and Political Union (WSPU) and was one of eighteen women to be jailed when they were charged by mounted police in Hyde Park in February 1907. After her time in prison she organised meetings and protests in Leicester and played a leading role

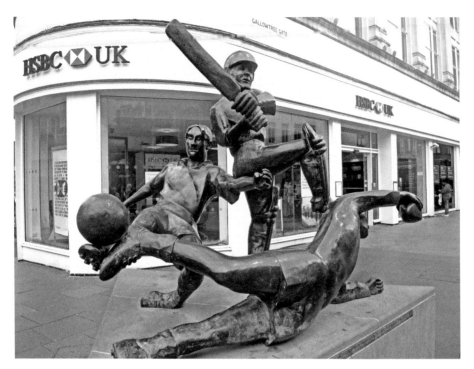

'Sporting Heroes' statue.

in forming the city's branch of the WSPU. In total she was jailed five times for her militant activities over a period of seven years. The statue of Thomas Cook stands appropriately outside the railway station. He organised the world's first package tour when he arranged an excursion from Loughborough to a temperance meeting in Leicester.

The statue of the Leicester seamstress on the corner of Hotel Street reflects the importance of the hosiery industry in the area for over three centuries. Socks and stockings were made in abundance for over two centuries. It was the men who operated the knitting machines while the women were engaged in seaming and embroidery. A statue in Gallowtree Gate celebrates some of Leicester's sporting heroes. It depicts three inter-linked sportsmen in action and commemorates the 1996–97 season when Leicestershire won the county championship in cricket, Tigers Rugby Club lifted the Pilkington Cup and Leicester City's footballers won the Coca Cola Cup. Other statues worthy of mention include the historic figures on the Clock Tower, the statue of Mahatma Ghandi in the Belgrave Road area and a mini replica Statue of Liberty on the Swan Gyratory roundabout.

A tour of some of these statues is a pleasant and interesting way of spending an afternoon. A good starting point is the Clock Tower in the Haymarket and most of the statues mentioned are just a short distance away.

North West Leicestershire, Hinckley and Bosworth

14. Ashby Castle and St Helen's Church

The ruins of Ashby Castle represent over 500 years of history. In the latter half of the fifteenth century William Lord Hastings enlarged and strengthened an existing manor house. An entirely new south courtyard was created by adding a new chapel, domestic buildings and a curtain wall incorporating a vast tower house (the Hastings Tower). Hastings, however, did not live long enough to enjoy his new home. On 13 June 1483 he was accused of treason by the future King Richard III who ordered his immediate execution. The lands and title remained within the Hastings family and his son, Lord Edward Hastings, consolidated his position by fighting for Henry Tudor at the Battle of Bosworth Field. The Hastings family continued to prosper and in 1529 George Hastings was created Earl of Huntingdon. He soon put in hand a number of improvements and additions to the castle. During the Civil War the castle was besieged by Parliamentarian forces. Although too strong to be taken by force of arms, an outbreak of plague and dwindling food supplies finally compelled the garrison to surrender in February 1646. Two years later the castle was 'slighted and made untenable'. After this the Hastings family moved to Donington Hall and the castle fell into decay. The present remains are extensive and include the Hastings Tower, much of the curtain walls, hall, solar, kitchen, buttery and pantry.

The nearby St Helen's Church dates mainly from the fifteenth century. Sir William Hastings, who was responsible for much of the work on the castle, was also responsible for rebuilding the church. Under his direction an impressive new church was created which included a chapel built to house the tombs of Hastings family members. The church also contains other interesting features. Under an arch on the north side of the church may be found the figure of a pilgrim in a long cloak. On his right is a broad-brimmed pilgrim's hat decorated with scallop shells to indicate that he had made the arduous pilgrimage to Compostela. Other scallop shells hang from

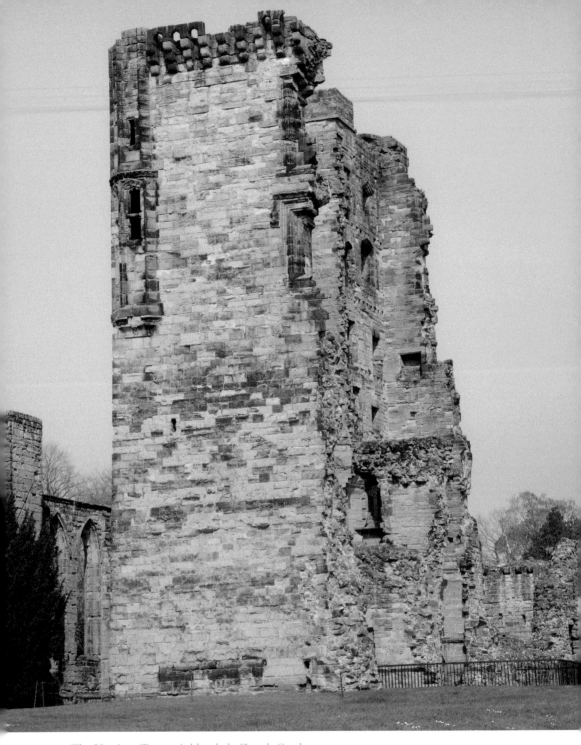

The Hastings Tower, Ashby de la Zouch Castle.

his belt and a pilgrim's staff lies by his side. Among other monuments is a painted bust of Margery Wright who died in 1623. An inscription records that she had given £43 to provide gowns for the old and needy of the town. The most unusual, and possibly unique, feature is a finger pillory which was used to control and subdue

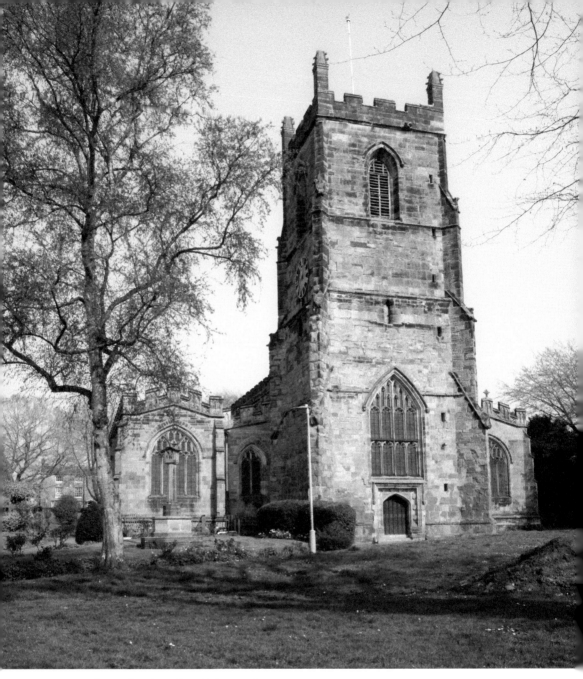

St Helen's Church, Ashby de la Zouch.

those who behaved in an unruly manner in church. A few years ago, the St Helen's Heritage Project was launched to enable local people and visitors to learn about the heritage of the church and its connections with the town. A new Heritage Centre has now been opened which contains interpretation panels and displays. Tours of the church are now offered on a regular basis and a programme of talks is held during the winter months.

The pay and display car park on South Street is just a few hundred yards from both the castle and the church.

15. The Century Theatre, Coalville

The Century Theatre is an unusual and probably unique structure which evokes both the austerity and optimism of post-war Britain. It was originally designed as a mobile theatre to bring entertainment to towns and villages across the country at a time when many conventional theatres had been damaged or destroyed in the Second World War. It was the brainchild of John Ridley, a theatre enthusiast and engineer at the Sketchley works in Hinckley. Together with two colleagues he designed an ingenious structure comprising stage, auditorium and dressing rooms, as well as box office, mobile living quarters, offices and stores. All this was housed in four trailers hauled by giant Crossley tractors which were surplus to requirements after the war. The total cost was £22,000, which was raised by private subscription. A number of well-known actors and writers contributed including Enid Blyton, Agatha Christie and Sir Lawrence Olivier.

The Century Theatre toured Britain for over twenty years until changes in traffic regulations brought an end to its travels in 1974. It found a permanent home at Keswick in Cumbria, where it served as the town's principal cultural venue for a

The Century Theatre, Coalville. (Courtesy of the Century Theatre)

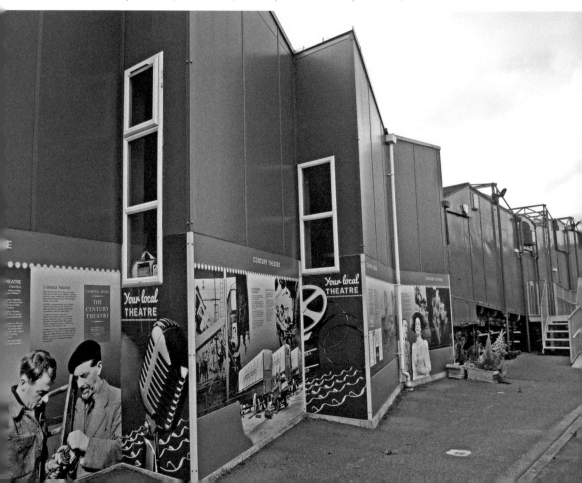

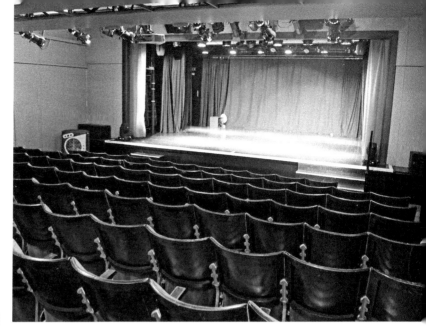

The auditorium of the Century Theatre, Coalville. (Courtesy of the Century Theatre)

further twenty-two years. In 1996 it returned home to Leicestershire. It was carefully reassembled, and reopened in October 1997. It now provides a venue for a wide variety of arts activities including classic drama, music, dance and comedy.

The Century Theatre is owned and managed by Leicestershire County Council. Directions and details of its current programme can be found on the website: www.centurytheatre.co.uk

16. Mount St Bernard Abbey

Mount St Bernard Abbey is a place of peace and tranquillity nestled in the Charnwood countryside, not far from Coalville. Founded in 1835, it was the first Roman Catholic monastery to be established in Britain since the Reformation. The present monastery was opened in 1844. It was designed by Augustus Pugin, a famous Victorian architect who was also responsible for the external decoration and interior of the Houses of Parliament. Only the nave of the church was completed by Pugin before he died. An octagonal chapter house and the church tower were designed by his son, W. E. Pugin, and completed in 1860 and 1871, respectively. Constructed in the Gothic Revival style, it soon attracted large numbers of visitors. The most famous of these included William Wordsworth and Florence Nightingale.

The monks who live at Mount St Bernard Abbey are a Roman Catholic community of the Order of Cistercians of the Strict Observance (sometimes known as trappists). They follow the Rule of St Benedict, which is summed up in their motto 'Ora et Labora' ('Pray and Work'). They rise at 3.15 a.m. in the morning and retire at 8.00 p.m. Their day is divided into periods of religious observance, private prayer and manual labour. Members of the community work on carpentry, pottery, bookbinding and candle making. Others make rosaries and greeting cards.

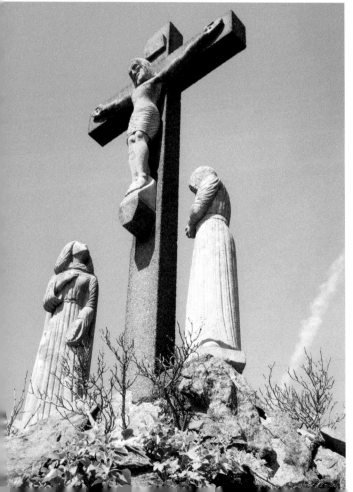

Above: Mount Saint Bernard
Abbey. (Courtesy of Mount
Saint Bernard Abbey)

Left: The 'Calvary' at
Mount Saint Bernard Abbey.
(Courtesy of Mount Saint
Bernard Abbey)

For many years the monks' main source of income came from a large dairy herd which they tended. When this ceased to be financially viable, they began to look for an alternative way of supporting themselves and working together for the common good. After considerable research and discussion, they decided to become brewers! Changes were made to the layout of the building to accommodate the equipment, and advice was sought from trappist breweries in Belgium. From 2018 the brewery became their main source of income and the principal focus of their labour. All the work from brewing to bottling and packaging is done by the monks, who also designed the label for their beer. This they named Tynt Meadow after the place where the monks first settled in 1835.

Mount St Bernard Abbey is a wonderful place to spend a quiet hour or two. It is possible to visit the church and ascend the calvary in the grounds. An abbey gift shop sells books, pottery, honey and greetings cards as well as the famous Tynt Meadow beer.

Mount St Bernard Abbey is located just a short drive from Coalville on Oakes Road LE67 5UL.

17. Look Out for Lock-ups!

Lock-ups are also known as round houses, watch houses, blind houses and clinks. They are typically small, windowless buildings that can be square, rectangular, octagonal or occasionally circular. At a time when there was no organised police force, they were used for the temporary incarceration of rogues, vagabonds and felons until they could be escorted to the nearest town by the village constable. More frequently they were used for confining drunks and troublemakers, who were usually released the next day with no record kept of their confinement. The village constable was generally responsible for the maintenance of the lock-up as well as the stocks and the village pound, where stray livestock were held. These lock-ups fell out of use when the County Police Act was introduced in 1839 and local police stations were built with their own holding facilities. As a consequence, the village lock-up became redundant and only a few have survived to the present day. There are three such lock-ups in North West Leicestershire: at Breedon on the Hill, Packington and Worthington, and two more at Ticknall and Smisby in neighbouring South Derbyshire. The round house at Breedon was built around the year 1793 and is made of local stone. It was constructed with an adjacent pound where stray animals could be held until released on payment of a fine. The round house was last used to hold prisoners in 1885. The one at Packington also dates from the eighteenth century but is octagonal in shape and is made of small red bricks. It lies on the edge of the village and was donated to the village by the Countess of Loudoun in 1997. The Worthington Round House is also octagonal in shape and is constructed of red brick with an octagonal spire. It is similar in size to other lock-ups and measures 3 metres across, with walls 1.5 metres high. It has a small slit window which may have been inserted during the Second World War

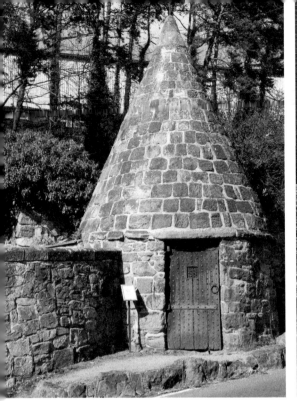

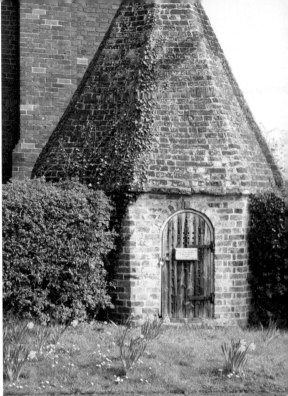

Above left: Breedon on the Hill Lock-up.

Above right: Packington Lock-up.

Left: Worthington Round House.

to convert it into a pillbox. There was previously a pinfold attached to the round house but this was demolished to make way for St Matthew's Avenue.

All three lock ups as well as their neighbours in Derbyshire can be visited in a single afternoon and there are pubs in each village where refreshments may be had.

18. Breedon on the Hill Church and Its Saxon Carvings

The most impressive collection of Saxon carvings in Britain is to be found in a little parish church in North West Leicestershire. The Church of St Mary and St Hardulph at Breedon on the Hill has a history which reaches back for over a thousand years. Standing on the site of an ancient hill fort, the first church to be built here was a Saxon

The Church of St Mary and St Hardulph at Breedon on the Hill.

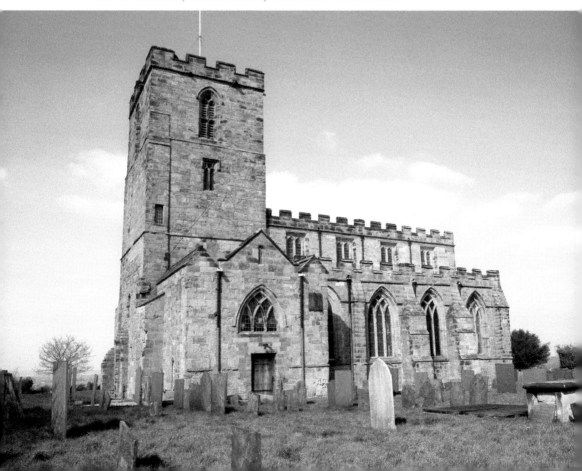

monastery which was established in the seventh century. This was an important site within the Kingdom of Mercia and became the burial place of a number of Anglo-Saxon saints. Following Viking attacks in the area it seems that the monastery fell into decline and disrepair. The Normans founded an Augustinian priory on the site and the Saxon carvings were incorporated into the new buildings. This new foundation never thrived and was seized by the Crown as part of the Dissolution of the Monasteries in 1539. Part of the monastic church was demolished but what now remains became the parish church. The surviving carvings comprise an extensive collection of vine leaves, geometrical interlace patterns, birds, strange beasts and depictions of warriors and mounted huntsmen. There is also a collection of individual human figures. The largest of these is a half figure holding a book in his (or her) left hand and giving a Byzantine blessing with the other. Cross fragments inside the church depict mythical beats and the story of Adam and Eve. The most important and significant of all these carvings is the famous Breedon Angel. Believed to be a depiction of the Angel Gabriel, it is widely regarded as one of the finest examples of Saxon figurative sculpture and probably the earliest carved angel in Britain. The sculpture is housed in the bell tower and is not accessible to the general visitor but a full-size replica has been created and is displayed in the south aisle of the church.

The church lies on a hill overlooking the village and is approached via a narrow road which leads directly to the church, postcode DE73 8AJ.

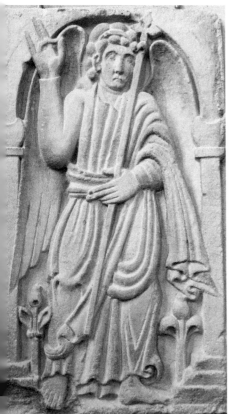

Left: The Breedon Angel.
(Courtesy of the Revd Mary Gregory)

Below: More Saxon carvings in Breedon Church.
(Courtesy of Revd Mary Gregory)

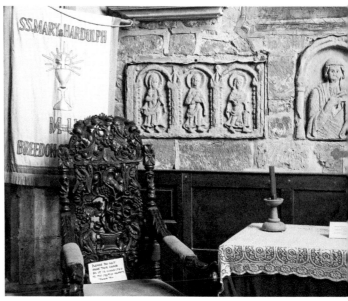

19. East Midlands Aeropark

The East Midlands Aeropark is a small aviation heritage centre located on the edge of Castle Donington. It is home to a collection of twenty-seven complete aircraft as well as four sections and a small number of aircraft undergoing restoration. A number of iconic aircraft are displayed including the Avro Vulcan strategic bomber, the BAC Lightning interceptor and three variants of the famous Hawker Hunter. The Vulcan was operated by the RAF from 1956 until 1984. It was designed to carry the Blue Steel missile which provided Britain's nuclear deterrent until the late 1960s. It was also a Vulcan bomber which made the daring raid on Port Stanley airfield during the Falklands War. The BAC Lightning played an important role in Britain's air defence during the Cold War era. Capable of flying at twice the speed of sound, its role was to protect Britain from potential attacks from nuclear-armed Soviet supersonic bombers. The Hawker Hunter first entered RAF service in 1954 and became one of the most successful jet fighters of its time. It served in a number of roles in both the RAF and several foreign air forces. The Hunters displayed at the aeropark include reconnaissance, training and Royal Navy variants. Other Cold War jets exhibited here include an English Electric Canberra, a De Havilland Vampire, a Blackburn Buccaneer and the cockpit of a Gloucester Meteor. Within the aeropark are two viewing mounds which overlook the main east–west runway of the East

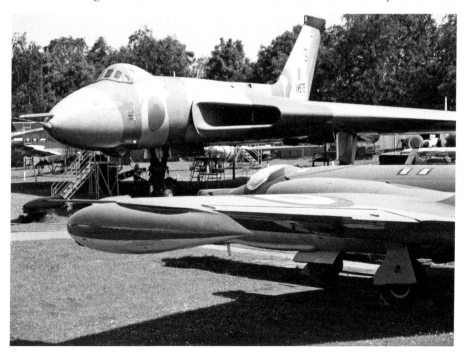

Avro Vulcan strategic bomber at the East Midland's Aeropark. (Courtesy of East Midlands Aeropark)

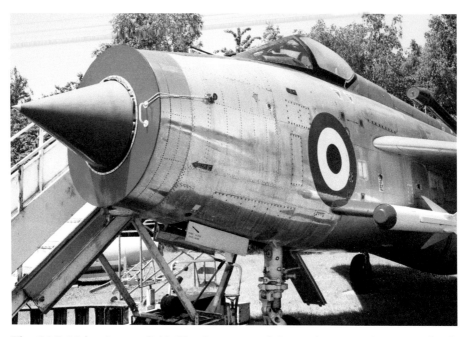

The BAC Lightening, a Cold War interceptor fighter. (Courtesy of East Midlands Aeropark)

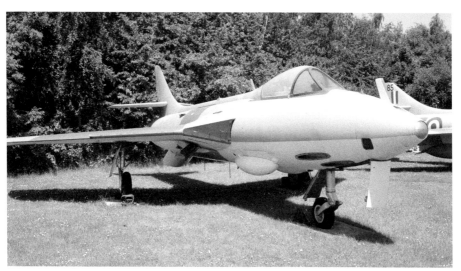

The Hawker Hunter fighter aircraft. (Courtesy of East Midlands Aeropark)

Midlands Airport. These provide visitors with an uninterrupted view of aircraft taking off and landing.

The aeropark is located at Hill Top, Castle Donington, DE74 2PR. It is open from Easter until the end of October each year. Full details may be found on the website: eastmidlandsaeropark.org

20. Moira Furnace Museum and Country Park

Moira Furnace is an important and iconic relic of the Industrial Revolution and is one of the earliest surviving coke furnaces in Britain. It was built by Francis Rawdon, the 2nd Earl of Moira, between 1804 and 1806. He planned to smelt iron ore using the local coal measures on his estate to provide the fuel required. A foundry was also established to produce castings. Unfortunately for the earl, the project was not a financial success. The furnace was in operation for only two brief periods: from July 1806 to May 1807 and from May 1810 to early in 1811. Problems with the operation and management of the furnace combined with the quality of the iron ore and the availability and suitability of coal supplies all contributed to its failure. The iron produced was of variable quality and the furnace consumed huge quantities of coal. It has been calculated that the amount of coal required to produce a ton of iron was twice that required elsewhere. It was clearly not a viable financial enterprise. Serious damage occurred later in 1811 which caused its final closure, for it was deemed that further operation was impossible without costly repairs. The foundry

Moira Furnace and the John Wilkes trip boat.

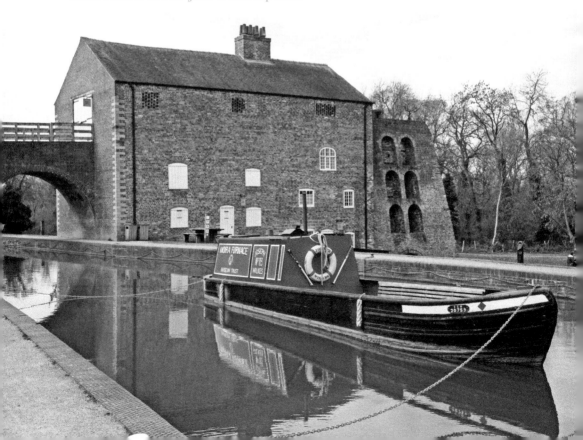

Restored limekilns on the banks of the Ashby Canal near Moira Furnace.

attached to the furnace remained in operation until the 1840s using iron ore imported from elsewhere. Ironically Moira Furnace survived because it was unsuccessful and consequently never rebuilt. It lay forgotten and abandoned for decades until it was eventually restored by the local council.

Today the Moira Furnace Museum and Country Park is a great place to visit. The furnace building has been fully restored and now houses a museum of industrial and social history. A few hundred yards away is a row of preserved limekilns. Visitors can also explore the woodlands or take a trip on the Joseph Wilkes narrowboat on a restored section of the Ashby canal. The craft village on the site includes a tearoom where refreshments may be purchased.

Moira Furnace is on Furnace Lane, Moira, DE12 6AT. Directions and details of opening times can be found on the website: moirafurnace.org

21. The Bosworth Battlefield Heritage Centre

The Bosworth Battlefield Heritage Centre tells the story of one of the most fateful and significant battles in English history. The Battle of Bosworth was fought on 22 August 1485 and marked the end of the Wars of the Roses. King Richard III was challenged for the throne by Henry Tudor. After a battle that lasted only a few hours Ricard III lay dead and Henry Tudor ushered in a new dynasty that was to change the face of Britain. Much has been written about the battle itself. Having landed in Wales, Henry Tudor began to march inland towards London. In response, King Richard III mustered an army at Leicester and a few days later deployed his troops on a hill just a few miles south of Market Bosworth. The two armies prepared for

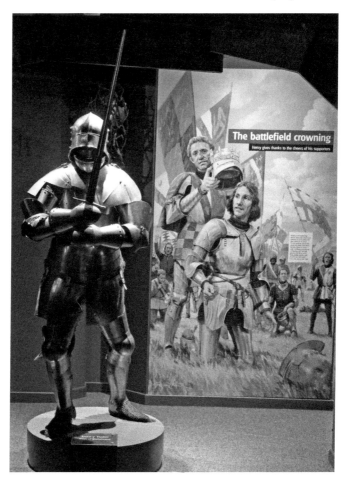

Part of the display within the Bosworth Battlefield Heritage Centre. (Image provided by Leicestershire County Council Museums Service)

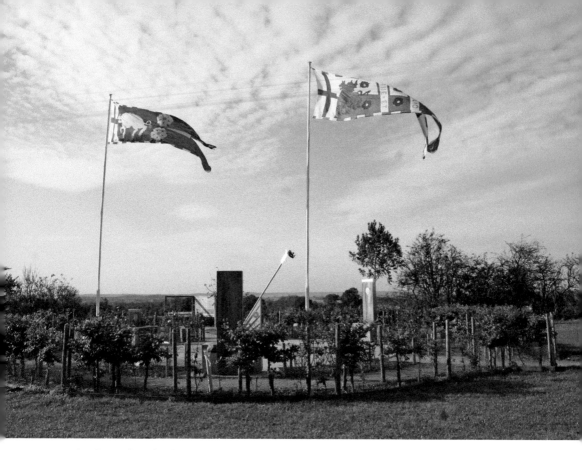

The flags of Richard III and Henry Tudor flying over the Bosworth Battlefield Trail. (Image provided by Leicestershire County Council Museums Service)

battle but there was also a third army on the field that day. Lord Thomas Stanley and Sir William Stanley commanded a force of around 5,000 men. They had been summoned by King Richard but they remained on the sidelines, refusing initially to commit their forces to either side. After several hours of fighting the outcome of the battle hung in the balance. It was at this juncture that Richard gambled everything on a charge across the battlefield in an attempt to kill Henry Tudor and win the day. It was then that the Stanleys intervened on the side of Henry. King Richard was unhorsed but fought bravely on until he was hacked to death.

The heritage centre contains eight exhibition galleries which use multi-media techniques to explain medieval warfare and tell the story of the battle. Other exhibits explore the impact of the new Tudor dynasty on such things as architecture and literature. Outside, a self-guided trail explains the key points of the battle and the parts played by the chief protagonists. The actual site of the battle has been the subject of some controversy. Recent research and archaeological surveys have pinpointed the site of the battle to be in fields more than a mile to the south-west. A new trail has been planned which will lead from the current heritage centre to the new location. As well as picnic tables there is a café on the site. A shop sells a variety of souvenirs.

The Bosworth Battlefield Heritage Centre is located close to Market Bosworth, postcode CV13 0AD. Full details of the opening times and special events may be found at www.battlefield.org.uk

22. Donington le Heath Manor House (1620s House and Garden)

Donington le Heath Manor House is believed to be the oldest house in Leicestershire and one of the oldest in the country. The building dates from the latter years of the thirteenth century although it is believed that an earlier building once stood on the site. The manor house was for many years owned by Charley Priory and then by Ulverscroft Priory in Leicestershire. After the Dissolution of the Monasteries it was sold to the Digby family. It was John Digby who altered and modernised the building, leaving the exterior very much as it looks today. In addition to installing new mullion windows he also converted the downstairs storerooms into a kitchen and parlour. A new internal staircase was constructed and the upstairs rooms were remodelled.

The house was later rented out to tenant farmers for over 300 years and was eventually used as a pigsty. It was purchased by Leicestershire County Council in

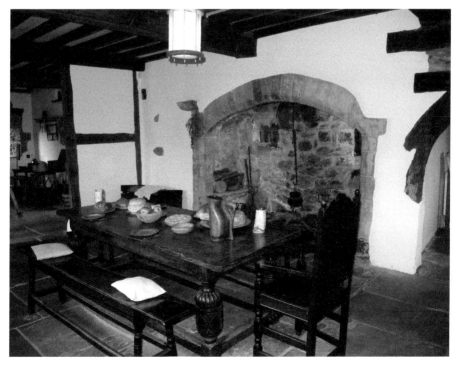

The kitchen/parlour at Donington le Heath Manor House. (Image provided by Leicestershire County Council Museums Service)

1965 and after a major restoration project was opened as a museum in 1973. In 2016 the site was refurbished and re-presented as the 1620s House and Garden. On the ground floor the visitor can now explore the scullery, kitchen/parlour, pantry/buttery and dairy. On the first floor are the great chamber, bedrooms and a study. All are presented as they would have been at the start of the seventeenth century. They have been furnished with a combination of original and replica furniture and utensils which visitors are encouraged to touch.

The house is set in gardens recreated in the style of the early seventeenth century and include flower gardens, an orchard, herb and vegetable gardens and a maze. A large stone barn houses a licensed tearoom.

The 1620s House and Garden is on Manor Road, Donington le Heath, LE67 2FW. Full details of the opening times and special events may be found at doningtonleheath.org.uk

Donington le Heath Manor House and Gardens. (Image provided by Leicestershire County Council Museums Service)

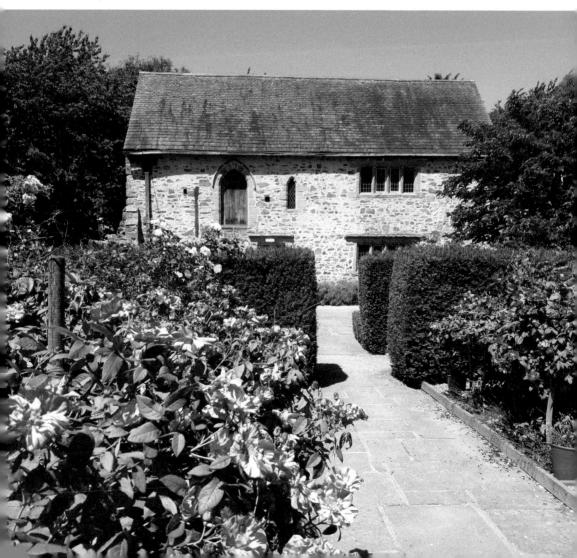

23. Staunton Harold Church and Hall

Staunton Harold has been described as one of the most beautiful and interesting places in England and one of its least-known treasures, Holy Trinity Church, is unusual and possibly unique for it is believed to be the only church to be completely planned, built and equipped during the Commonwealth period. It was built by Sir Robert Shirley, an ardent Royalist and something of a thorn in the side of the government. He may have been a member of the Sealed Knot, a secret Royalist organisation, and was imprisoned on a number of occasions. The building of this chapel was a deliberate snub to the Puritan government of which he disapproved. An Order in Council declared, 'He that could afford to build a church could no doubt afford to equip a ship.' This he refused to do and on 5 May 1654 a warrant was issued to 'seize, inventory and secure all his estates'. His arrest soon followed and he was imprisoned in the Tower of London. He died there in November 1656 at the age of twenty-seven amid rumours that he had been poisoned. His magnificent chapel is in the care of the National Trust and is open to the public. It was built in the

Below left: Staunton Harold Church.

Below right: Entrance to the Staunton Harold Estate.

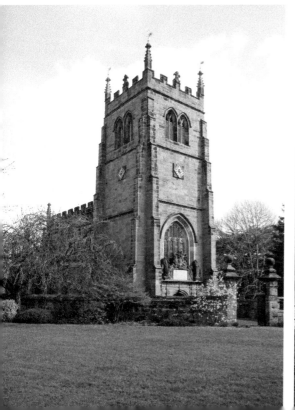
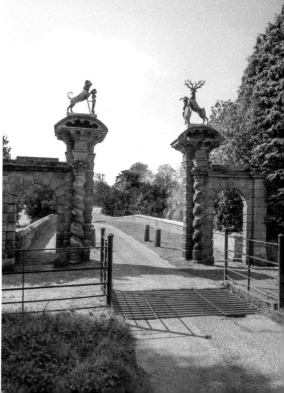

Gothic style with a Jacobean interior, which remains largely unchanged. Features of interest include box pews and a pulpit with a lectern. The eighteenth-century screen is believed to be the work of the famous Derbyshire ironsmith Robert Bakewell.

Staunton Harold Hall dates from the early years of the eighteenth century but incorporates remains of two earlier houses. It has been described as 'one of the most beautifully proportioned and situated great houses in Britain'. To the west of the house was a stable block which at present contains shops, craft workshops and a café. Members of the Ferrers family lived here until 1954 when it became a Cheshire Home for the disabled. It was later leased to the Sue Ryder Foundation. It is today a private home but parts of the building are used for weddings and conferences.

The estate is open every day of the year except Christmas Day and Boxing Day. It is located just a few miles from Ashby de la Zouch and is best approached via the B587. Post code LE65 1RW.

24. Triumph Visitor Experience

The Triumph Visitor Experience is a twenty-first-century gem and an amazing exhibition located at the Triumph Factory on the edge of Hinckley. The story of this historic brand is told through nine themed areas which include Bloodline, Performance, Iconic and Design. Bloodline traces the history and development from the earliest bikes to the latest production models. Exhibits include an example of the Triumph No. 1, built in 1902, and the Model 8 (Trusty), which was used by the Allied forces during the First World War. 'Performance' features some of the race-winning and record-breaking machines built by the company. These include the Tiger 100 Grand Prix Racer (1948) and the TT winning Daytona 675R (2014). The most visually exciting exhibit is probably the Texas Cee-Gar. On 6 September 1956 Johnny Allen took this out onto the Bonneville Salt Flats in the USA and smashed the world land speed record. Powered by a Thunderbird engine, Allen averaged 214.4 mph, setting a record which lasted until the 1960s.

A number of Triumph motorcycles have starred in film and TV. Exhibits in the 'Iconic' section include the motorbikes ridden by Tom Cruise in the final chase scenes of *Mission Impossible II* and by Steve McQueen in the 1963 war movie *The Great Escape*. The Triumph Bonneville Scrambler in which Dr Who (played by Matt Smith) rode up the Shard is also displayed. A 'Wall of Fame' features the Triumph machines ridden by film stars and celebrities such as Richard Gere, Angelina Jolie, Clint Eastwood and Marlon Brando. The Design theme traces the development of a new motorbike from initial concept through to its final manufacture. The visitor experience also includes a merchandise shop and the 1902 Café. Factory tours are available at an additional cost. Details may be found on the website.

The Triumph Factory Visitor Experience is located at Triumph's main factory site: Normandy Way, Hinckley LE10 3BZ. Opening times and information about factory tours may be found on the website: www.triumphmotorcycles.co.uk/Visitor-Experience

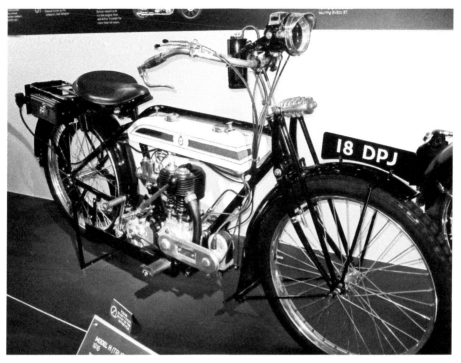

The Triumph Model 8, Trusty. (Courtesy of the Triumph Visitor Experience)

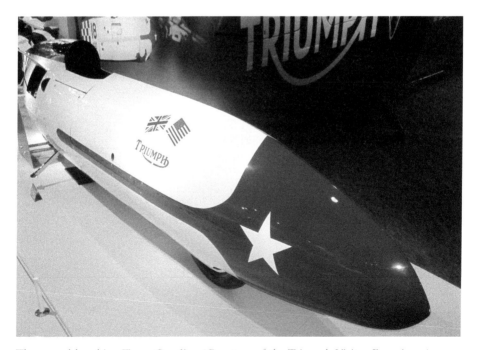

The record-breaking Texas Cee-Gar. (Courtesy of the Triumph Visitor Experience)

Charnwood and Melton

25. The Melton Heritage Trail

The Melton Heritage Trail offers visitors a suggested tour around a dozen heritage sites in Melton town centre. It is available online and as a leaflet which may be obtained from the local information centre. There are, however, four buildings of particular historic interest which are all within a few hundred yards of each other. The first of

St Mary's Church at Melton Mowbray.

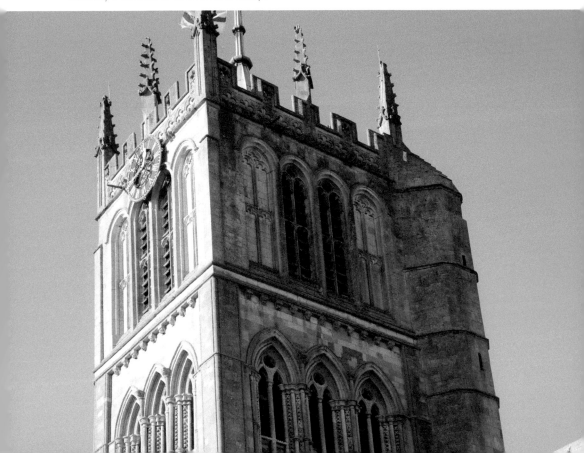

these (though not included in the official trail) is the Old Courthouse in Church Street. Now home to a photographic shop and studio, this building has a fascinating history spanning almost 500 years. Once part of the Old Swan coaching inn, it was for a period the town's courthouse. It was here that Justices' sessions were held and prisoners detained before trial or awaiting transfer to the crown court. Just a few yards away is St Mary's Church. This has been described as one of the largest and finest parish churches in Leicestershire. Although dating from the twelfth century, it was much restored by George Gilbert Scott in the 1850s. It is built on a plan more generally associated with a cathedral and was in fact considered to fulfil this role when the new Diocese of Leicester was created in 1926. The tower and spire dominate the town. The belfry contains ten bells, the earliest of which dates from the fourteenth century. The church also contains a number of notable monuments dating from the fourteenth to the eighteenth century. A stunning new stained-glass window depicts the tree of life. A short stroll through the churchyard leads to Burton Street and here the visitor will find two more historic buildings. Anne of Cleves' House (now a pub and restaurant) dates from the fourteenth century. It was originally a monastic house and later home to twelve chantry priests. Following the Dissolution of the Monasteries it was granted to Thomas Cromwell. He was later executed by King Henry VIII, who granted the property to Anne of Cleves (his fourth wife) as part of a divorce settlement. Directly opposite are the Maison Dieu Bede Houses. Built in 1640, these almshouses were the gift of Robert Hudson, a wealthy London merchant and a native of Melton Mowbray. His coat of arms can still be seen on the front of the building. Initially they provided accommodation for six poor old bachelors or widows. The Revd Henry Storer increased this to twelve in 1720. All four buildings can be visited in a short period of time.

A good starting point for this mini-tour is the Old Courthouse in Church Street.

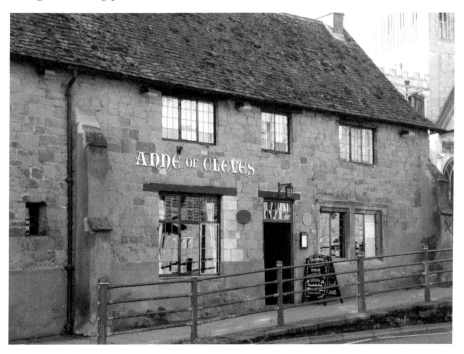

Anne of Cleves' House at Melton Mowbray.

26. Melton Mowbray Pork Pies and Stilton Cheese

Stilton cheese has been described as the 'King of English cheeses'. The origins of this famous cheese are shrouded in mystery, with many conflicting accounts surrounding its pedigree. It is believed that it was first produced in Melton Mowbray although Frances Pawlett, a noted cheesemaker from Wymondham, is widely regarded as the individual who set the characteristics of the modern Stilton cheese as early as the 1720s. According to the Stilton Cheesemakers Association the first person to market Blue Stilton was Cooper Thornhill, the landlord and later owner of the Bell Inn on the Great North Road in the village of Stilton. From here he was able to use the stagecoach routes to sell his cheese in London and elsewhere throughout the country. For a cheese to use the name Stilton it must be produced in one of the three counties of Derbyshire, Nottinghamshire and Leicestershire. At the time of writing only six dairies are licensed to make Stilton cheese and three of these are in Leicestershire at Melton Mowbray, Long Clawson and Saxelby.

Leicestershire's other culinary claim to fame is the Melton Mowbray pork pie and there is a symbiotic relationship between the two products. Whey is a by-product of

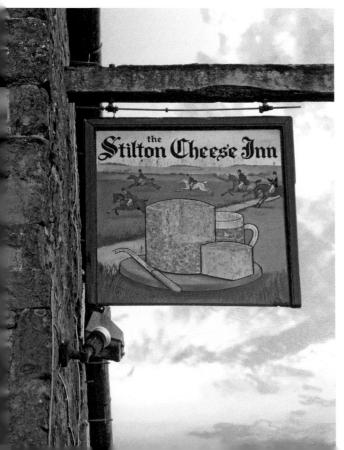

Pub sign illustrating Stilton cheese and its links to the fox-hunting fraternity.

cheese production and this was fed to large numbers of pigs which were raised locally for pork. The Melton Mowbray pork pie is distinctive in a number of ways. It is made with a hand-formed crust. The uncured meat is chopped rather than minced and it is baked free-standing. As a consequence, the sides bow outwards. Its rapid increase in popularity was linked to the sport of fox hunting. From the eighteenth century these pies were carried by hunt servants to be eaten as a midday snack. Before long wealthy members of the fox-hunting fraternity began to follow their example. On their return from a weekend's hunting they demanded that these pies be served in their London clubs. Commercial production and marketing of this famous pie dates from 1832 when Edward Adcock began to transport pies to London by stagecoach. The development of railways in the nineteenth century further increased its availability and popularity. Today the Melton Mowbray pork pie is widely available throughout the country. The firm of Dickinson and Morris in Melton Mowbray has been baking Melton Mowbray pork pies since 1851 and claim to be the oldest remaining bakers of the authentic pork pie in the town centre.

The Long Clawson factory cheese shop is open on certain dates throughout the year. Details can be found on its website: www.clawson.co.uk. Ye Olde Pork Pie Shoppe, owned by Dickinson & Morris, is on Nottingham Street, Melton Mowbray, LE13 1NW.

Ye Olde Pork Pie Shoppe (Dickinson and Morris) at Melton Mowbray.

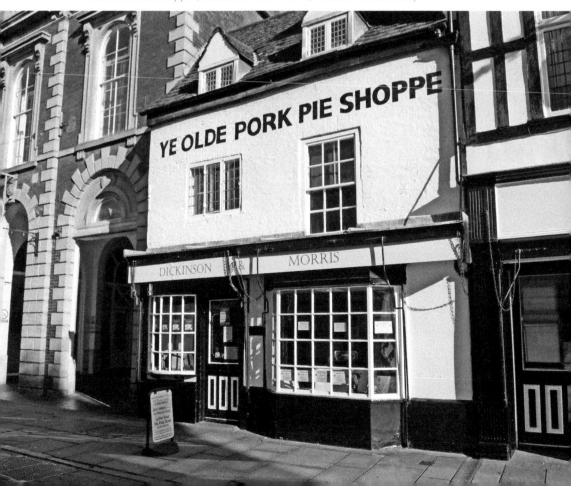

27. Burrough Hill Iron Age Hill Fort

Burrough Hill is an Iron Age hill fort located around 7 miles from Melton Mowbray. Its dramatic ramparts dominate the landscape and provide stunning views of the surrounding countryside. These hill forts are to be found all over the country and were designed as a fortified refuge or defended settlement. People lived in simple roundhouses within these fortifications and livestock could be brought within the ramparts in the event of an attack. Burrough Hill is one of the largest of such fortifications in the East Midlands. Some historians believe that it may have been the ancient capital of the Corieltauvi tribe. It was built close to a number of important trackways of the period and its defences were impressive. The fort occupied a 690-foot-high hill. It was surrounded by earthen ramparts which may have been topped by a rough timber palisade. There is also evidence of huge double gates and a guard chamber. The site has been excavated on several occasions. Archaeologists discovered a number of objects from the Iron Age including pottery and bone fragments, quern stones and around a hundred examples of Iron Age metalwork. Other finds provided an insight into the social life of the inhabitants, and these

The Trig Point and ramparts at Burrough Hill Iron Age Hill Fort.

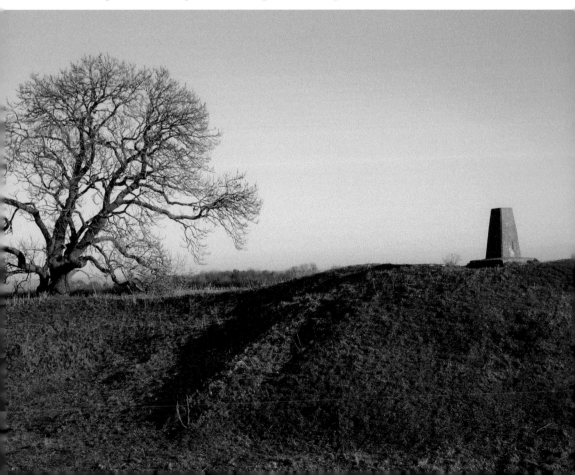

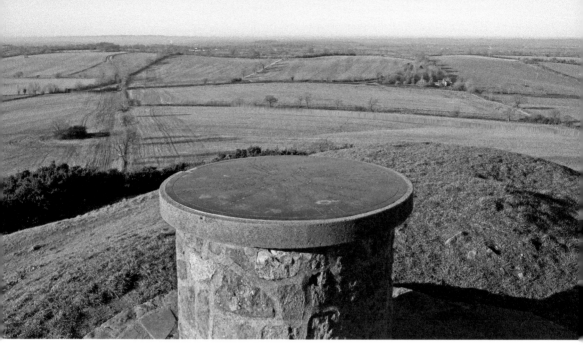

The view from the topograph at Burrough Hill Iron Age Hill Fort.

included bone dice, gaming pieces, a polished bone flute and a beautifully decorated blue glass bead from a necklace. The most exciting discovery came in 2014 when a rare Iron Age chariot was found. Experts believe that this may have belonged to a chieftain or other person of high status. The chariot had been dismantled and may have been buried with its owner as part of a religious ceremony.

The hill fort continued to be occupied during the Roman period and possibly even later. During the Middle Ages the interior of the hill fort along with much of the surrounding area was used for farming. The area later became popular as a venue for fairs, festivals and steeplechasing. Edward VIII as Prince of Wales came here on a number of occasions, and it was while staying at the nearby Burrough Court that he first met Mrs Wallis Simpson. Burrough Hill Country Park, which contains the hill fort, is open during daylight hours.

There is a pay and display car park on Somerby Road, Burrough on the Hill, LE14 2QZ.

28. Belvoir Castle

Belvoir Castle is without doubt Leicestershire's finest stately home. It occupies a prominent position which commands impressive views over the Vale of Belvoir. For over five centuries it has been the ancestral home of the Dukes of Rutland. The present castle was built over a lengthy period in the early years of the nineteenth century and is the fourth such building on the site. The castle remains

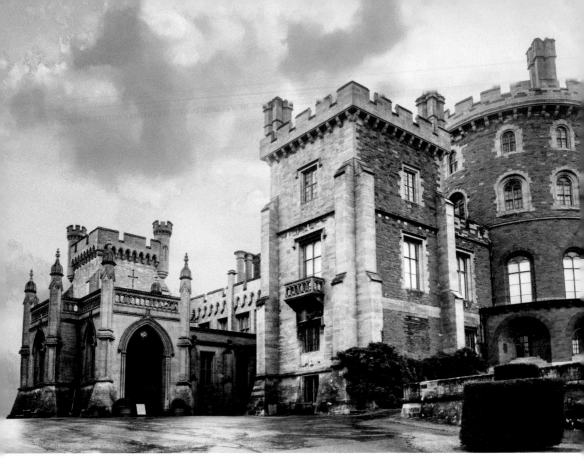

Belvoir Castle. (Courtesy of Belvoir Castle)

a family home although it is open to the public on a regular basis. Visitors are able to tour a number of lavish state rooms including the elegant Elizabeth Saloon, the State Dining Room, the King's Rooms and the Picture Gallery.

The Elizabeth Room was created by the wife of the 5th Duke and is designed in the opulent French style of Louis XIV. It is probably the only room in the castle which has remained unchanged since its creation. The King's Rooms, a suite of three, were used by George IV when he visited as Prince Regent. They are all decorated with intricately painted Chinese wallpaper. The Roman-inspired State Dining Room was used for many of the 5th Duke's birthday parties. Its massive table can be extended to seat thirty guests in comfort. The food at these parties would have been prepared in the castle's kitchens and pastry room and these too are open to the public.

Belvoir Castle has one of the largest private art collections in the country. The Picture Gallery contains a portrait of Henry VIII by Holbein as well as important works by Van Dyke, Sir Joshua Reynolds and Thomas Gainsborough. In total, over twenty rooms are open to the public. Some of these contain important collections of furniture, porcelain, silk, tapestries and Italian sculpture. The extensive grounds contain both formal gardens as well as woodland walks.

Belvoir Castle is located between Nottingham and Grantham, just off the A607, postcode NG32 1PE. Details of the opening times can be found at www.belvoircatle.com

29. Loughborough Carillon and the Charnwood Museum

Loughborough Carillon is the town's most distinctive landmark and is used in much of its publicity and marketing. Standing in Queen's Park, it was built as a memorial to the local men who gave their lives during the First World War. Standing 46 meters high, it was the first grand carillon to be built in this country. The choice of a carillon tower as an appropriate memorial monument may have been influenced by similar structures in parts of Belgium since many of Loughborough's 'fallen' are buried there.

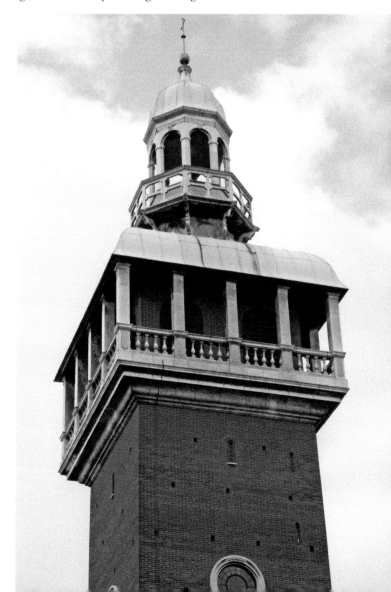

Loughborough
Carillon.

The Carillon has forty-seven bells ranging in size from 6 kg to a massive 4,211 kg. All were cast at Taylor's Bell Foundry in the town. Like church bells, each bell plays a different note, but instead of being allowed to swing freely they are struck by 'clappers' operated by a system of levers. Many of the bells are inscribed with the names of relatives or friends and some were 'sponsored' by local companies who wished to commemorate former employees. Today the tower houses a military museum and provides a focus for the town's annual Remembrance Service.

Also in Queen's Park is the Charnwood Museum. This was once the town's public swimming baths which was built in 1897 to celebrate Queen Victoria's Diamond Jubilee. The swimming baths closed in 1975, and after being used for a variety of purposes the building reopened as a museum in 1988. It has been described as the best small museum in Leicestershire. It explores the history of the area through a number of themes including Coming to Charnwood, the Natural World, Living Off the Land and Earning a Living. One of the most stunning exhibits is a light aircraft suspended from the ceiling of the museum. This was made by the Auster Aircraft Company at the village of Rearsby in 1947. It is one of 3,800 aircraft that were built there between 1939 and 1969. This particular example (G-AJRH) was the winner of the 1956 King's Cup Air Race. Elsewhere in the museum are displays relating to Ladybird Books, Lady Jane Grey, Charnwood Forest and the prehistory of the area.

Queen's Park is located near the centre of Loughborough. There is a pay and display car park in Granby Street, adjacent to the park, postcode LE11 3DU.

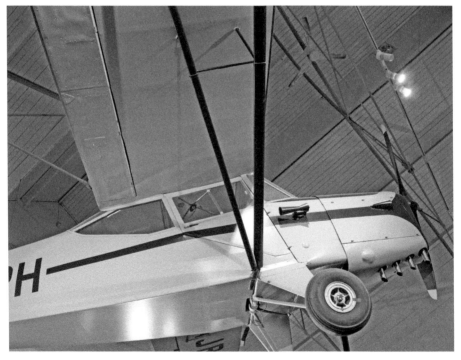

Auster Aircraft suspended from the ceiling at the Charnwood Museum. (Courtesy of Leicestershire County Council Museums Service)

30. Taylor's Bell Foundry and Museum

Taylor's Bell Foundry in Loughborough is the last surviving bell foundry in Britain. The Taylor family have been producing bells since 1784, first in St Neots and then from 1821 at Oxford. The company moved to Loughborough in 1839 and opened their first foundry at a site on Packhorse Lane. Their first commission was to recast the bells of All Saints' Church in the town. The choice of Loughborough as its new site allowed the company to expand. Its links to the canal system and the new railway network provided the means by which raw materials could be imported, and finished bells easily transported throughout the kingdom and beyond. In 1860 the company moved to its present site on Freehold Street. Its biggest commission came in 1881 when the firm was given the task of casting a giant bell for St Paul's Cathedral. Great Paul, as it was known, weighed a total of over 17 tons and was transported to London on a specially constructed trolley hauled by two traction engines. The company continued to prosper and by 1892 Taylor's had become the largest bell foundry in the world.

Taylor's Bell Foundry in Loughborough.

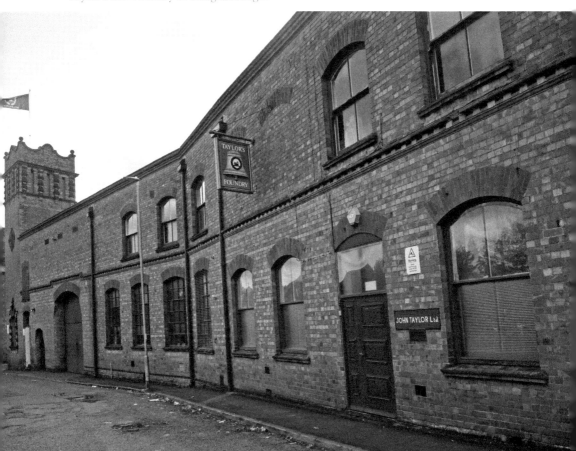

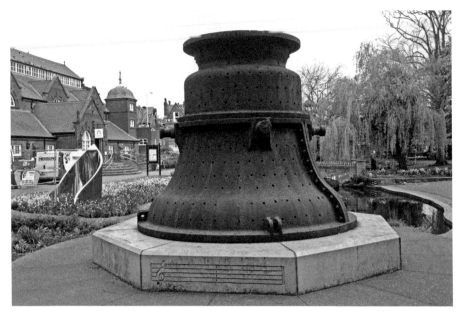

The Great Paul bell casing in Victoria Park, Loughborough.

In the decades that followed, the company was responsible for casting hundreds of bells for churches and public buildings throughout the world. Manufacturing methods have changed little over the centuries. Molten bell metal (an alloy of copper and tin) is poured into a casting mould comprising an inner core and an outer case. The newly cast bell is then tuned by removing metal from the interior case using a lathe. Tours of the works and the museum can be organised to accommodate groups of ten or more. During the tour all the processes from moulding and casting to the final tuning and fitting up are described in detail. There is also a fascinating museum showing the history of the company.

Full details may be found on the company's website (taylorbells.co.uk). At the time of writing the museum was not open to individual visitors and is only available as part of a tour. Taylor's Bell Foundry and Museum is on Freehold Street, Loughborough, LE11 1AR.

31. The Barrow upon Soar Kipper

The Kipper is the nickname given by the people of Barrow to the fossilised remains of a plesiosaur which was discovered in 1851 by workmen digging in a lime pit near the centre of the village. This prehistoric marine reptile lived approximately 150–200 million years ago at a time when warm seas covered the whole area. It is believed that these creatures behaved very much like sea turtles today. They used

their fins as paddles and came ashore to lay eggs. They had strong jaws and incredibly sharp teeth which allowed them to eat fish as well as any other animals that may have inhabited the seas at that time. In 1952 stylised images of this plesiosaur were placed on the traffic island known as *Jerusalem* at the bottom of the High Street. Since then the people of Barrow upon Soar have adopted the 'Kipper' as the village emblem. It features on the offices of the parish council and is used all over the village as well as in several local publications. The image even appears on the shirts of the village football team! The skeleton of the plesiosaur is now on display at the New Walk Museum, Leicester, with a full-size replica at Charnwood Museum, Loughborough.

There is much more of interest in the village. The Roundhouse was built in 1827 as a lock-up for the restraint of criminals, drunks and other nuisances. It was later used to house the village fire engine, and then the village bier for carrying a coffin. In more recent times it has been used as an exhibition room. Not far away is Bishop Beveridge House. This is one of the oldest buildings in Barrow and is reputed to be the birthplace of William Beveridge, a renowned theologian and the Bishop of St Asaph from 1704 until 1708. Other places of interest in the village include Holy Trinity Church, the seventeenth-century almshouses and the old cottages in Church Street.

Barrow upon Soar is around 3 miles from Loughborough, just off the A6.

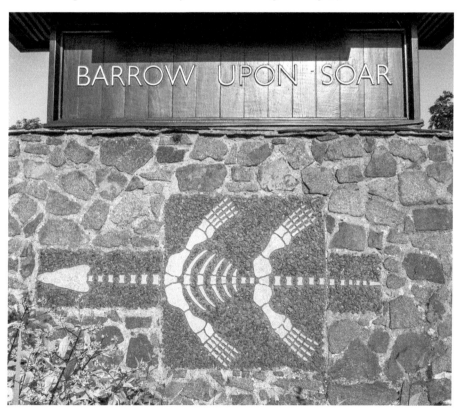

The Barrow upon Soar kipper.

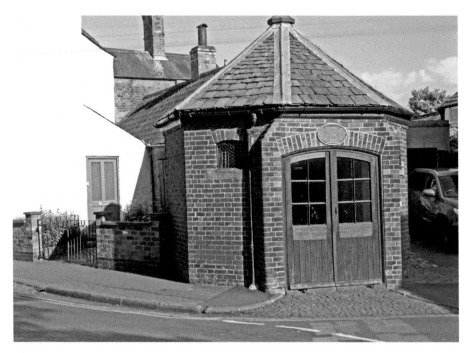

The Baron upon Soar Lock-up and Bier House.

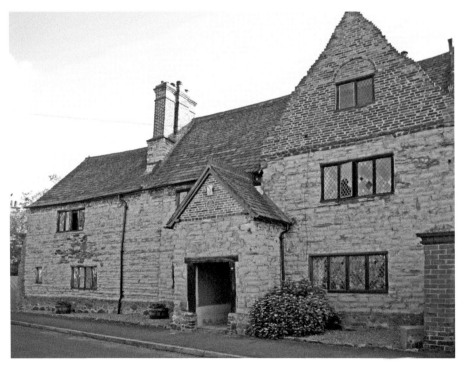

Bishop Bevan's House at Barrow upon Soar.

32. Beacon Hill Country Park

Beacon Hill's history can be traced back over thousands of years. It was originally a hill fort which was established by the people of the Bronze Age. Here they grew crops, herded their animals and defended themselves against hostile neighbours. It may also have been a centre of trade or a place where bronze implements were produced. Various Bronze Age artefacts have been found in the area including a bracelet, two spear heads, an axe head and an axe mould. For many years the area was privately owned but in 1947 it was purchased by Leicestershire County Council. In the early 1970s it was designated as a Country Park and has since become one of the most popular visitor attractions in the county. Covering an area of over 300 acres, the country park consists of mixed woodland, grassland, open heathland, wetlands and rocky outcrops. It is one of the highest points the county and a toposcope indicates some of the places and landmarks that can be seen from the summit. The open heathland of the park provides an important habitat for a wide range of flora and fauna. The ancient breeds of cattle that graze there play a vital role in encouraging the growth of heathland plants. Manx Loughtan and Hebridean sheep also contribute to the preservation of the landscape. In a separate area of the park a native tree collection has been created. There is much here for the visitor to see and do. A natural play area for children has been created using timber

View from the Beacon Hill Trig Point.

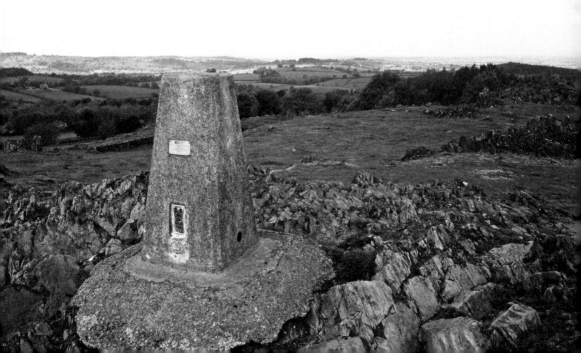

Carving of an axeman at Beacon
Hill Country Park.

grown within the park. Walkers, cyclists and horse riders all make use of a track
which loops around the edge of the park. A number of wooden chainsaw sculptures
depicting the history and heritage of the area are situated at various locations. Some
of the most impressive include a Bronze Age farmer, an axeman, a shepherd and even
a wizard! Beacon Hill Country Park is a pleasure to visit throughout the year. Visitors
can enjoy carpets of bluebells in the spring, wildflower meadows in the summer and
a riot of autumn colours later in the year.

 Beacon Hill Country Park is close to the village of Woodhouse Eaves. There are
car parks on Beacon Road at LE12 8SP and on Breakback Road at LE12 8TA.

33. Swithland Slate

Swithland slate is perhaps the most ubiquitous of Leicestershire's gems. Roofs and
tombstones made from this local material are a familiar sight in Leicestershire today
even though the extraction of slate ceased during the last quarter of the twentieth
century. Swithland slate was obtained from a variety of sites around the southern
borders of Charnwood for around 2,000 years but the main quarrying took place in the
eighteenth and nineteenth centuries in Swithland, Groby, the Brand and Woodhouse
Eaves. It was first quarried by the Romans who used it as a roofing material.

A stone cottage in Swithland village.

The first written evidence of slate quarrying in the area dates from the early years of the fourteenth century and the first reference specifically to the Swithland quarries appears in 1343 when the quarries at Swithland and Groby Park are mentioned in the records of the Borough of Leicester. In 1337–38 work on Leicester Castle included '2,000 slates bought from John Bateman with cartage from Swithland for 3s 1d a thousand'. Bradgate House, once the home of Lady Jane Grey, was also roofed with Swithland slate. For many years Swithland slate was quarried on a small scale but by the nineteenth century a few industrial-scale quarries were extracting slate from depths of more than 180 feet and at some places beam engines were being used to drive saws and polishing tables. Swithland slate was also used for a wide variety of other products including gateposts, milestones, fireplace surrounds, cattle and dog troughs, dairy utensils and cheese presses. More unusual are the clock faces as at Belgrave Parish Church, which is square and fixed diagonally, and at Groby, which is circular. Swithland slate is, however, best known for the many thousands of headstones which adorn churchyards throughout the county. The earlier examples date from the later years of the seventeenth century. These were at first fairly basic in design but more ornate lettering and the introduction of carved images began to appear in the early eighteenth century. These developments were aided by the widespread availability of pattern books which contained examples of different styles of lettering and provided useful guidance for local craftsmen. The images which were carved onto these headstones were based on established and widely understood iconography. Images associated with death and mortality include skeletons, skulls, bones, hour glasses and the tools of the sexton. Later examples contain images representing hope of resurrection and the means of salvation. Around 10,000 headstones can be found in churchyards throughout Leicestershire with particularly fine examples at Wymeswold, Gaddsby and All Saints' churchyard in Leicester.

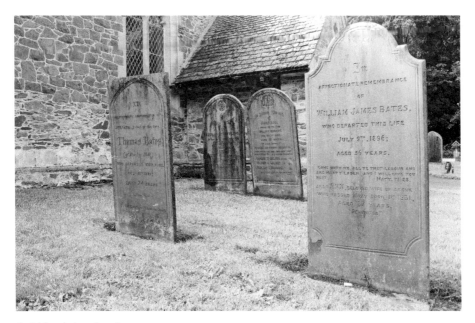

Swithland slate headstones.

Swithland is a linear village in the Borough of Charnwood and is located between Cropston, Woodhouse and Woodhouse Eaves. The centre of the village may be found at Main Street LE12 8TQ.

34. Watermead Country Park

The Watermead Country Park is a network of artificial lakes created by gravel extraction over a period of almost two centuries. Lying in the valley of the River Soar and the old Grand Union Canal, it runs along the path of these watercourses for a distance of around 2 kilometres. A number of waymarked routes allow visitors to explore a wealth of landscapes, wildlife habitats and spectacular viewpoints. There is much to see in and around the different lakes. On the edge of King Lear's Lake is a sculpture depicting King Lear mourning the death of his daughter. According to legend Lear was a king who ruled over the local area in the eighth century BC and is reputed to have been buried nearby. Shakespeare used this legend as inspiration for his play. The Jurassic Play Trail which runs around the lake includes a ribcage climbing frame, a mini 'henge' and a plesiosaur play mound. A little further south a portrait bench portrays two Bronze Age people and an aurochs (an extinct wild ox), the remains of which were discovered nearby. Other interesting features to be found in the park include wood carvings of a number of animals and birds. It is possible to follow the river southwards to reach Watermead Park (South) which is managed by Leicester City Council.

The park is located north-east of Leicester, immediately adjacent to the A46, between the village of Syston and Wanlip. The main entrance can be accessed from Wanlip Road, Syston, near the Hope and Anchor pub, LE7 1PD.

Above: Statue of King Lear at Watermead Country Park.

Right: Wooden carving of a heron at Watermead Country Park.

Harborough

35. Market Harborough Grammar School and St Dionysius Church

Market Harborough Grammar School is one of the most unusual and distinctive small buildings in the county. The founder and benefactor was Robert Smyth. Born in Market Harborough into a poor family, he travelled to London around the year 1570 to find fame and fortune. He built a successful career and eventually became City Solicitor and Comptroller. He never forgot his native town and in 1607 he provided £40 to pay for a schoolmaster. In 1614 a schoolhouse was built in accordance with Smyth's detailed instructions. The ground floor was 'to keepe the market people drye in tyme of fowle weather'. The schoolroom above stood on ten supporting columns. It was here that the master taught the boys the rudiments of Latin grammar, Religious Education and Arithmetic. Smythe's endowment provided for the education of poor children but it is believed that throughout the seventeenth century masters also accepted fee-paying pupils. It was not always easy to maintain discipline among the boys and in November 1672 there was a riot. For several days the pupils locked out the master and created mayhem in the market below. The building is no longer a school but is used for a variety of community activities.

The adjacent St Dionysius Church dates mainly from the fourteenth and fifteenth centuries. Externally its most significant feature is a sturdy tower, surmounted by a superb broach spire. A fine sundial on the south face of the tower dates from 1762. The interior of the church contains a number of interesting features. The Royal Arms over the tower arch are made of plaster and were erected in 1660 at the Restoration of Charles II. The sanctuary contains two interesting items of eighteenth-century furniture: a fine carved chair, known popularly as the Bishop's Chair, and a long wooden chest which was used for the safe-keeping of registers, plate and vestments. In the South Porch there are four charity boards which detail

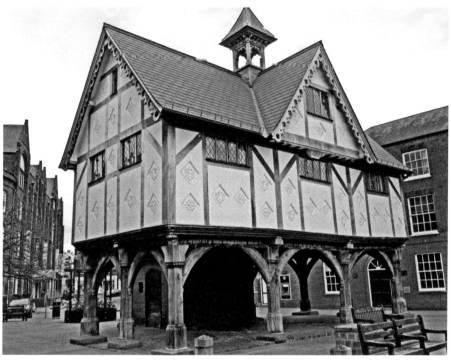

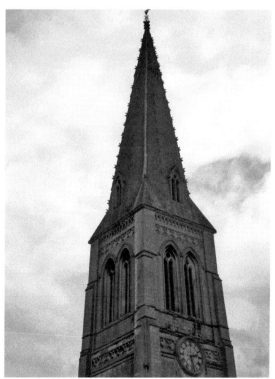

Above: Market Harborough Grammar School.

Right: St Dionysius Church, Market Harborough.

some of the bequests made for the benefit of the town. The earliest donations date from the reigns of Henry VII and Henry VIII and provide for the repair of highways and bridges and the relief of the poor. For many the glory of the church lies in its stained-glass windows. The Victorian east window is the work of John Hardman and depicts scenes from the life of Christ with a row of Old Testament figures at the bottom.

The Old Grammar School and St Dionysius Church stand next to each other on High Street in the centre of Market Harborough.

36. Harborough Museum and the Hallaton Hoard

Harborough Museum is housed in the Symington Building, an iconic Victorian corset factory in the heart of Market Harborough. Located on the first floor of the building, the museum is home to a fascinating range of exhibits which explore the history of the town through a number of themes including Growing up, Sickness and Health, Across the Counter, Religion and Belief, and Living off the Land. One of the most interesting of these exhibits is Faulkner's Boot and Shoe Workshop. The business operated in the town from the 1840s until 1987, when the workshop was dismantled and reconstructed at the museum. There are also dedicated displays showcasing some of the antiquities and curiosities of the Harborough Historical Society collection. These include a Victorian magic lantern, an Ancient Egyptian mummified cat's head and fragments of Roman pottery. The most important exhibit within the museum is undoubtedly the famous Hallaton Treasure. Of international importance, this was unearthed in 2000 when the Hallaton Fieldwork Group discovered an open-air hilltop shrine containing multiple Iron Age coin hoards, a silver gilt Roman parade helmet and debris from feasting. Other artefacts discovered at the site included a unique silver bowl, silver and bronze ingots and blue glass 'eyes'. Historians believe that these were all ritual deposits offered to the gods, perhaps asking for their protection or intercession. The skeletons of three dogs were also found at the site. They may have been sacrificed and buried to guard the shrine. After analysis and expert conservation, many of the objects from the Hallaton Hoard are now displayed in the Treasure Gallery of the museum. The museum shares the building with a number of organisations and acts as a hub for Harborough District Council and Leicestershire County Council services. The ground floor offers a café and ice-cream parlour.

The Harborough Museum is housed in the Symington Building on Adam and Eve Street, Market Harborough. Admission is free and full details of the opening times and special exhibitions may be found at www.harboroughmuseum.org.uk

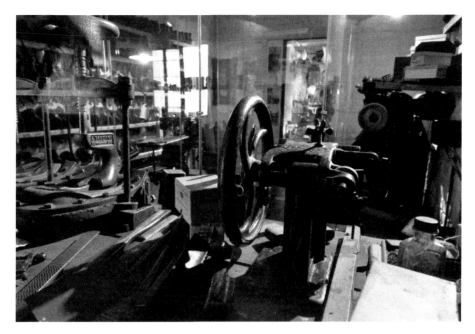

Above: The boot and shoe workshop at Harborough Museum. (Image Provided by Leicestershire County Council Museums Service)

Right: Roman parade helmet – part of the Hallaton Hoard. (Image Provided by Leicestershire County Council Museums Service)

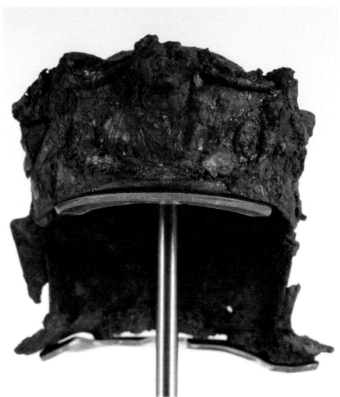

37. Kibworth and 'The Story of England'

If I were to choose one gem that summarised and symbolised all the entries in this book it would be the parish of Kibworth (comprising the villages of Kibworth Beauchamp, Kibworth Harcourt and Smeeton Westerby). In 2010 a book and TV, series both entitled *The Story of England*, used the village of Kibworth to tell the story of England from the earliest times to the present day. The project began in 2009 when fifty-one test pits dug by the villagers revealed evidence of occupation from prehistoric times to the present day. Discoveries included debris from Georgian coaching inns, framework knitters' houses and railway navvies' camps. A magnetometry survey revealed evidence of an Iron Age settlement and a complete Roman villa. Another survey confirmed the existence of a Norman motte-and-bailey castle. The investigation also relied on a wide range of documentary evidence including medieval poll tax records and the list of Black Death victims from the

The Coach and Horses pub at Kibworth.

village court book. Sixteenth-century wills provided an insight into occupations and the standard of living at the time. More recent documents included the diaries of a suffragette written from Holloway Prison. All this told the remarkable story of a typical English village. Saxon farmers ploughed the fields here for centuries and after 1066 Norman rule was reinforced by the building of a castle. The Black Death wiped out around 70 per cent of the population. The Reformation had a considerable impact on the village and during the reign of Edward VI the altar rails of the church were ripped out. At some time during the 1640s the font was removed by the Puritan vicar, John Yazley. The Industrial Revolution led to the development of Kibworth Beauchamp and this period of the parish's history is represented by framework knitters' houses, a Methodist chapel and Navvies Row (built to house those working on the construction of the Midland railway). The war memorial records the names of those who gave their lives in the two world wars. There remains much of interest in the village. Ten information boards tell the story of the place, and a number of significant buildings still stand. These include St Thomas' Church, the Old House, the Coach and Horses public house and an old windmill.

The village of Kibworth is well signposted. The best starting point is the information board at the Coach and Horses pub on Leicester Road, Kibworth Harcourt, LE8 0NN.

The Old House, Kibworth.

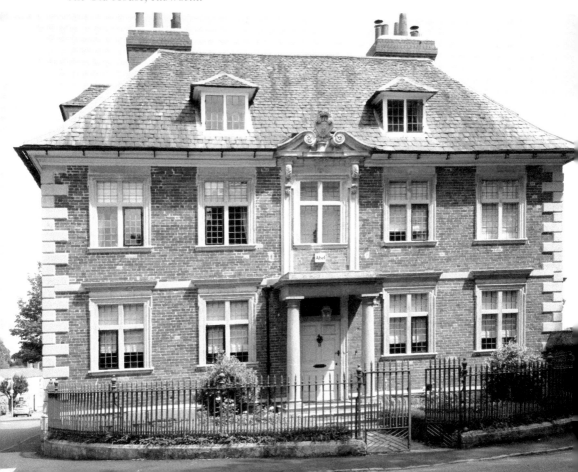

38. Gargoyles and Grotesques at Tilton on the Hill

The Church of St Peter lies in the heart of the village of Tilton on the Hill. Parts of the fabric date from the twelfth century but most of the present church was constructed in the thirteenth and fourteenth centuries. The church is notable for a remarkable set of carvings both inside and out. They include corbels, gargoyles and a number of ancient carvings on the walls. It is believed that many of these carvings were executed by a group of itinerant masons known as the 'Mooning Men Group'. Their work is characterised by the cheeky trademark of a mooning man. Tilton has two such carvings. One of the arches in the north aisle is adorned by a splendid set of carved animals illustrating the fable of the fox and the goose. These include the depiction of a fox with a goose in its mouth, a crowned lion and a number of other creatures which are not easily identifiable – possibly a lion and a monkey. The corbels, which support the roof timbers, provide a fascinating insight into the headwear of the

The Church of St Peter, Tilton on the Hill.

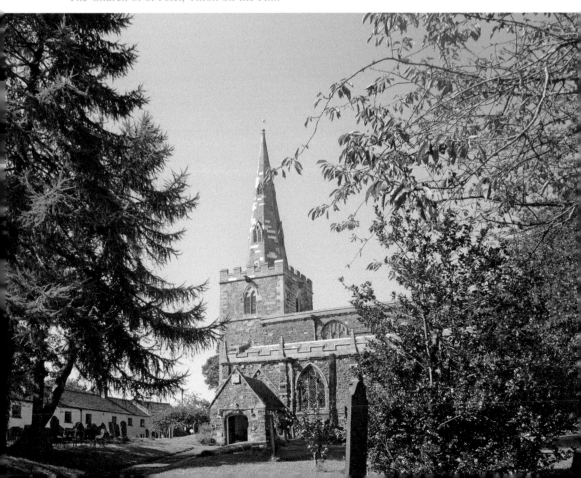

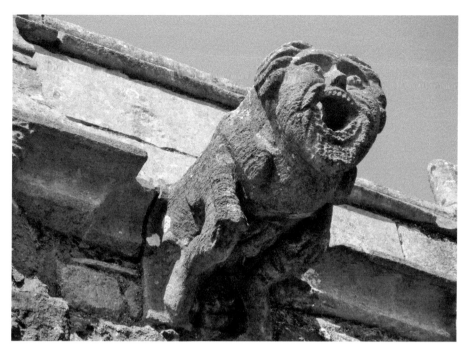

Gargoyle on the Church of St Peter at Tilton on the Hill.

period and one shows a screaming man supporting the roof with his hands. The gargoyles on the exterior of the church are particularly striking. Most date from the fifteenth century and depict a variety of strange and grotesque beasts. Experts believed that they are the work of an individual mason who worked on a number of churches in Leicestershire. Other features of interest within the church include the tombs of the Digby family and an impressive twelfth-century font.

St Peter's Church is on Main Street, Tilton on the Hill, Leicestershire, LE7 9LB.

39. Lutterworth and the Dawn of the Jet Age

A stunning silver statue of a jet aircraft stands in the centre of a road island on the edge of Lutterworth. This is a replica of the Gloster Whittle E28/39, which was the first British aircraft to be powered by a jet engine. It stands as a monument to Sir Frank Whittle who invented the jet engine and did much of the development work in Lutterworth. Whittle was a brilliant RAF officer who was seconded to develop his

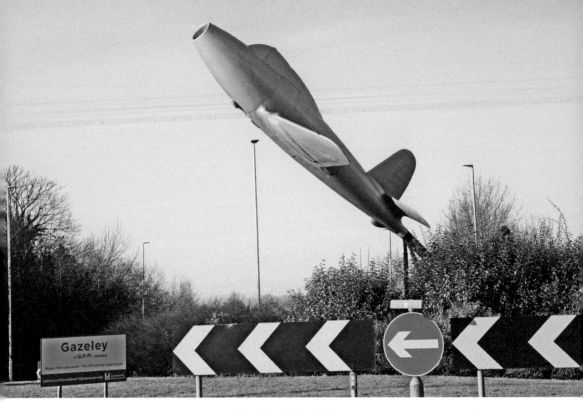

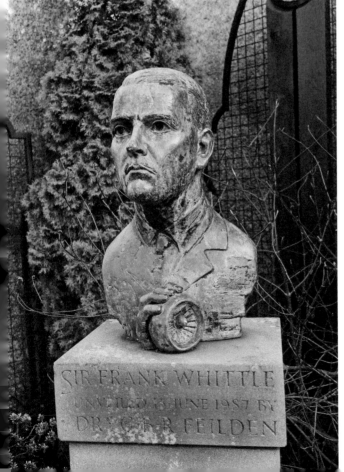

Above: The Frank Whittle
Roundabout at Lutterworth.

Left: The bust of Sir Frank
Whittle in the Memorial Garden,
Lutterworth.

ideas on jet propulsion. He founded a company called Power Jets with the support of the British Thomson-Houston company. Based initially in Rugby, Power Jets moved to Lutterworth in 1938 and it was here that Whittle did much of his pioneering work. The workshops and test facility were both located here and within a few months he was able to test a more advanced prototype engine. By now the government was keen to make progress. In April 1941 a test version of the flight engine was assembled and run at Lutterworth just as the first Gloster Whittle aircraft was completed. Britain entered the jet age on 1 May 1941 when the Gloster Whittle E28/39, powered by one of Whittle's engines, took to the skies. The people of Lutterworth are justly proud of their adopted son. A bust of this aviation pioneer stands on a plinth in the town's Memorial Garden and a green plaque was recently placed on the site of the engineering works where much of the development work took place.

The memorial stands just south of Lutterworth at the junction of A426 and the A4303. The bust of Sir Frank Whittle is in the town's Memorial Garden in Church Street. The green plaque may be found on the side of a building on Leicester Road, L17 4NH.

40. Laund Abbey

The building known as Laund Abbey began life as the Augustinian Priory of St John the Baptist. It was founded sometime before 1125 and was generously endowed. The priory was not without its troubles for in 1366 a complaint was made to the Bishop of Lincoln that the prior was guilty of showing favouritism to some of the canons whilst dealing harshly with others. He was also accused of neglecting to sleep in the dormitory or eat in the refectory. Only a few years later the king intervened to stop another prior (Thomas Coleman) from beating, imprisoning and expelling the canons, selling the priory's possessions and wasting its woods. Around this time the priory passed into the temporary possession of Richard II who founded a chantry here in 1393. The priory continued to have an unsettled history and in 1528 an official report noted that the refectory was in a ruinous condition and the church rather dilapidated. The prior and sub-prior were censured for failing to treat the brethren with sufficient charity and one of the canons was said to be causing discord in the house. Laund survived the first phase of the dissolution of the monasteries but the priory was surrendered to the Crown in December 1539. Thomas Cromwell, Henry VIII's chief minister and the man responsible for closing down the monasteries, allocated Laund for himself but was executed for high treason in the same year that construction of a new manor house on the site was begun. His son, Gregory, lived there until 1603.

The present Elizabethan manor house is typical of the period with slightly projecting wings to the east and west which result in an H-shaped plan. The chapel is all that remains of the original priory church. Some of the stained glass is medieval and Pevsner described the monument to Gregory Cromwell as 'one of the purest monuments of the early Renaissance in England'. Laund Abbey is today a Christian

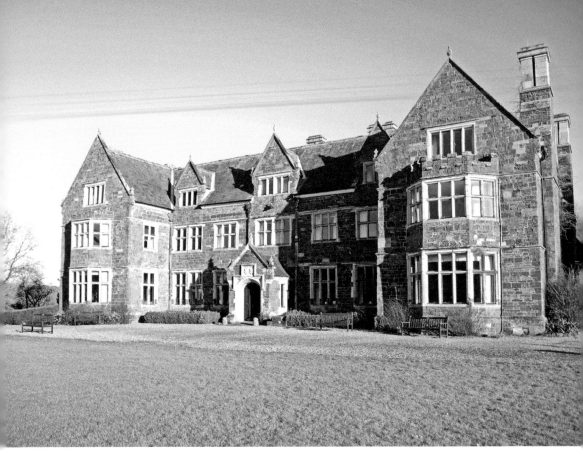

Laund Abbey.

Retreat House and Conference Centre supported by the Church of England dioceses of Leicester and Peterborough. The tearoom and grounds are open every day for visitors.

Laund Abbey lies 14 miles east of Leicester and 30 miles west of Peterborough. It is easily accessible by car and the postcode for your satnav is LE7 9XB.

41. Wigston Framework Knitters Museum

Wigston Framework Knitters Museum is a fascinating time capsule which illustrates an important aspect of Leicestershire's industrial heritage. Hosiery played a vital role in the economy of the county for over 200 years. Stockings were manufactured

Wigston Framework Knitters Museum. (Courtesy of Wigston Framework Knitters Museum)

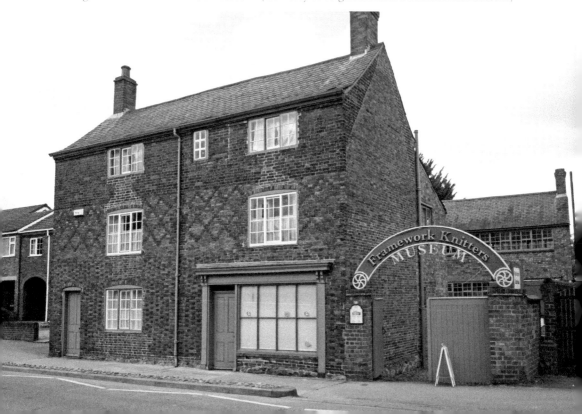

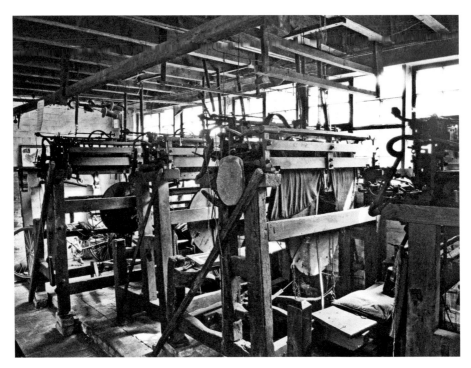

Knitting frames. (Courtesy of Wigston Framework Knitters Museum)

on mechanical knitting machines which were known as stocking frames. In 1845 there were over 500 stocking frames operating in the village of Wigston alone. Framework knitting was essentially a domestic operation which involved the whole family, with the husband or older male members of the family operating the frames while the wife was engaged in seaming and embroidering the hose. The children would spend their time winding the yarn onto bobbins. In many places, cottages were custom built with large windows to admit maximum light to the workroom. Purpose-built workshops were later constructed in some areas, which housed up to twenty or so frames.

The Wigston Framework Knitters Museum comprises a master hosier's house and workshop. When the last master hosier, Edgar Carter, died in 1952 the workshop was locked and left leaving a unique record of the working life of a hosier. Inside are eight hand frames used for making gloves, mitts and fancy ribbed tops for golf hose, together with all the moulds and tools for each machine. The house dates from the end of the seventeenth century and is furnished with a number of period artefacts. The museum has a small shop and light refreshments are also available.

Wigston Framework Knitters Museum is located at 42–44 Bushloe End, Wigston Magna, LE18 8BA. Further information including details of opening times and admittance charges may be found at www.wigstonframeworkknitters.org

42. Kirby Muxloe Castle

Kirby Muxloe Castle is an interesting building in many respects. It was built as a status symbol to demonstrate the owner's wealth and power. Despite its broad moat, gun ports and crenelated towers, it was intended as a grand mansion or even a palace rather than a fortification. The man responsible for its construction was William Lord Hastings, who became the victim of a power struggle between different factions towards the end of the Wars of the Roses. Construction began in October 1480. This was a substantial building project involving bricklayers, masons, labourers, gardeners, carters and ditchers. Preparatory work included the redirecting of a brook to feed the moat and the building of a cart track for the

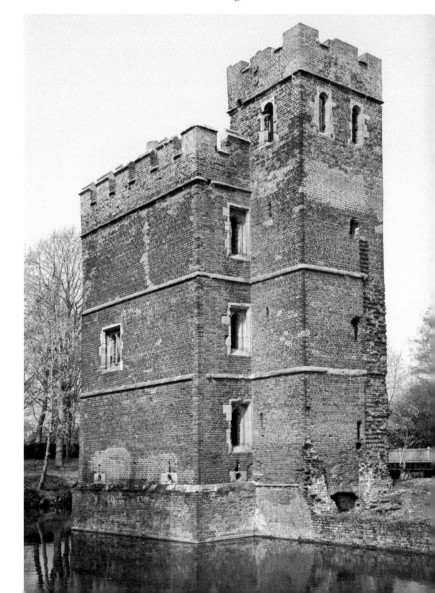

The tower and moat at Kirby Muxloe Castle.

carriage of stone. A certain Anthony Yzebrond, a Fleming, was paid ten pence a week to supervise the production of bricks and before long, huge numbers were being fired each week. Work continued at a fairly brisk pace for almost four years, although in winter it was sometimes halted by cold weather. When this happened, the walls were covered with straw or stubble to protect them from frost. Work slowed considerably in 1483 following the execution of Lord Hastings. Although a favourite of Edward IV and Chamberlain of the Royal Household, he lost the trust of the future King Richard III who ordered his summary execution. Only a few weeks later the family was restored to its rights and titles. Hastings' widow continued construction for a brief period but building petered out in 1484 and only sporadic work was done after that time. Eventually the site was abandoned and fell into disrepair.

Today the castle is a romantic ruin in the care of English Heritage. The remains include a substantial gatehouse and an impressive west tower. Decorative brickwork includes the initials 'WH' for William Hastings, part of his coat of arms, a ship and a jug. The moat is still in water and the gatehouse is approached via a wooden bridge where the drawbridge and portcullis once stood.

Kirby Muxloe Castle lies 4 miles west of Leicester off the B5380. Access is via Oakcroft Avenue, Kirby Muxloe, LE9 2AP.

The gatehouse at Kirby Muxloe Castle.

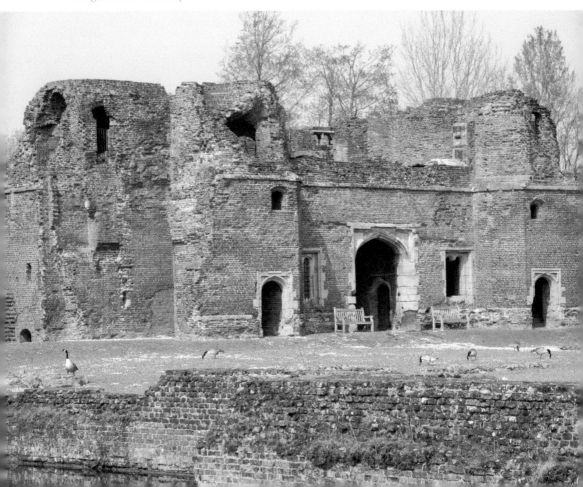

43. Glenfield Tunnel

Lost and forgotten by many people, the Glenfield Tunnel is an outstanding achievement of early railway engineering and an icon of the steam age. The tunnel was built by the Leicester and Swannington Railway, which was formed to transport coal from the mines in the Swannington area to Leicester, from whence it could be conveyed by canal to other parts of the country. The scheme received royal assent in 1830 and construction began almost immediately. A sandstone ridge at Glenfield necessitated the driving of a tunnel over a mile long. This proved to be a more difficult task than had been anticipated. Due to the porous nature of the sandstone the whole tunnel had to be lined with bricks, which added considerably to the cost of construction. The first part of the line opened on 17 July 1832 when a train hauled by the *Comet* locomotive and driven by George Stephenson made the first journey through the tunnel. A covered carriage was provided for the directors of the railway company but other passengers and a brass band were conveyed in open coal wagons. The cost of transporting coal was considerably reduced, making many of Leicester's industries more profitable. It was not originally intended to carry passengers but in response to demand a carriage was hastily built. Eventually, both first- and second-class carriages were provided but facilities for passengers remained primitive with local inns and tiny cabins serving as booking offices. Initially there were no

The entrance to the Glenfield Tunnel. (Image provided by Bill Pemberton)

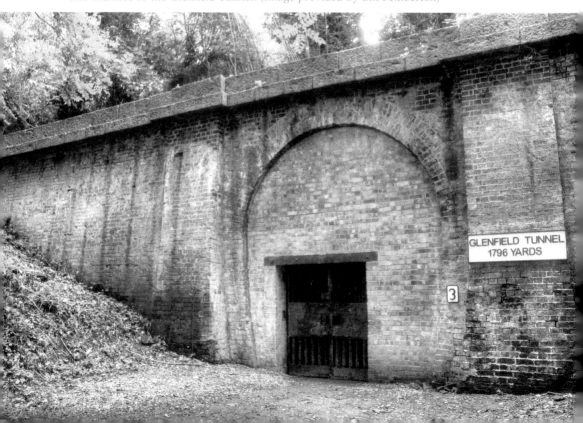

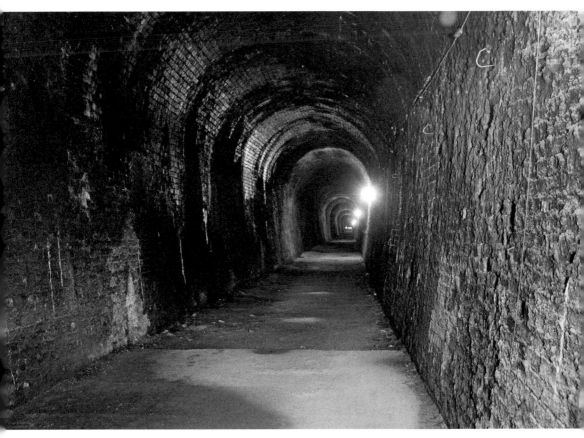

Interior of the Glenfield Tunnel. (Image provided by Bill Pemberton)

dedicated passenger services and passenger carriages were merely attached to goods trains. Passenger trains stopped in 1928 and the goods line finally closed in 1966. The tunnel served a different purpose in the 1970s when it was used by Marconi to test military lasers. It was eventually bought by Leicester City Council for the sum of five pounds, but in 2007–08 it had to be strengthened using a series of concrete reinforced hoops to prevent its collapse.

The Glenfield Tunnel is not open to the general public. It is cared for by the Leicestershire Industrial History Society, who organise regular tours of the tunnel during July and September. There is no charge for these tours but donations towards the society's work with schools are welcome. Bookings must be made in advance at lihsvisit@viginmedia.com

Rutland

44. Rutland Water

Rutland Water is owned and operated by Anglian Water. It was originally known as Empingham Reservoir and was created in the 1970s to supply water to large parts of the East Midlands. It has a surface area of 4.19 square miles and is one of the largest man-made lakes in Europe. Initially there was much opposition to the scheme but this is now largely forgotten and the area attracts over a million visitors each year. Rutland Water has been described as the playground of the East Midlands with water

Normanton Church, Rutland Water.

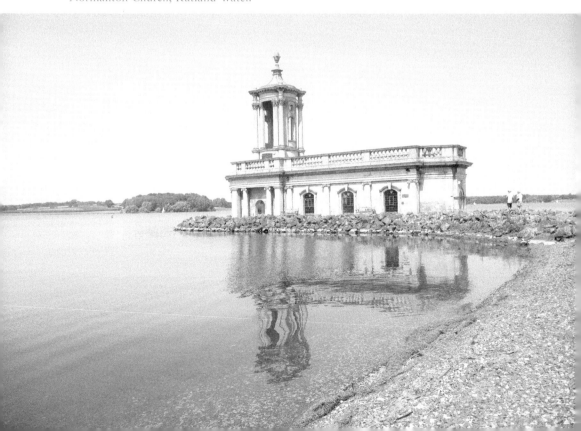

sports, nature reserves, cycling and walking facilities and an outdoor adventure centre. Rutland Water has always played an important role in nature conservation. There are bird-watching hides on the western shore and a nature reserve at Lyndon. Ospreys began breeding here in 2010 and they remain a popular attraction. There are excellent facilities for water sports enthusiasts. Rutland Sailing Club is based at Edith Weston and canoes, rowing boats, sailing dinghies and wind surfers can all be hired at Whitwell. For those who wish to explore the water in a more leisurely fashion, the *Rutland Belle* pleasure cruiser operates round trips from Whitwell. The 23-mile perimeter track is popular with walkers and cyclists and there are cycle hire facilities at Whitwell and Edith Weston. The most iconic feature of Rutland Water is undoubtedly Normanton Church. This was saved from demolition in the 1970s when much of the surrounding area was flooded. An image of the church appears on much of the publicity used to promote the area.

A good starting point to explore Rutland Water is the car park at Whitwell, LE15 8BL. There are three other car parks at Sykes Lane, Normanton and Barnsdale.

The *Rutland Belle* pleasure cruiser.

45. Oakham and Its Castle

The Great Hall of Oakham Castle has been described as the finest surviving example of Norman domestic architecture in Europe. It was built between 1180 and 1190 and is the only surviving part of a much larger castle or fortified manor house. Archaeological evidence suggests that the castle was originally surrounded by a moat and a curtain wall, with towers placed at strategic points along its length. A gatehouse and a drawbridge completed its defences. Today the castle is most famous for its collection of horseshoes. The origin of the strange custom by which a horseshoe has to be presented to the castle by each noble visitor is shrouded in mystery, but modern visitors will see a vast array of such shoes of all shapes and sizes.

Near to the castle is the twelfth-century church of All Saints. Its impressive spire dominates distant views of the town for several miles in all directions. Nestled in the churchyard is the town's original grammar school which dates from the sixteenth century and has the date 1584 etched on its south front. The market square is home to an ancient butter cross where dairy products were sold. It also shelters the town stocks. These are unusual as they have holes for five legs! Only a few yards from

Oakham Castle.

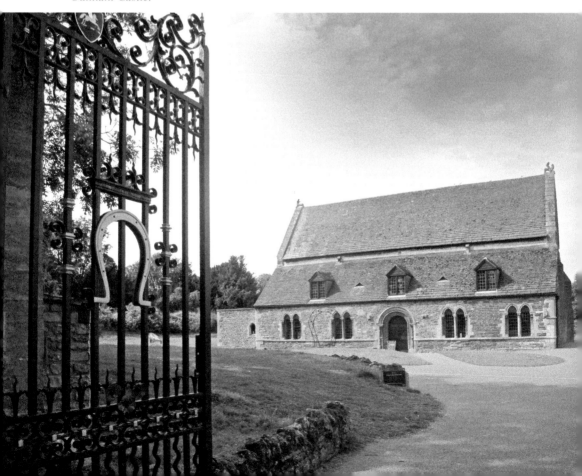

The market cross and stocks at Oakham.

here the visitor will find the entrance to the present Oakham School. Oakham is also home to the Rutland County Museum. This is located in Catmos Street, in the old Riding School of the Rutland Fencible Cavalry which was built in 1794–95. Opened in 1969, it houses a collection of objects relating to local rural and agricultural life, social history and archaeology. Oakham is a pleasant place to spend a day. The church, castle and museum are all well worth a visit and there are lots of other places of interest in the town. There are a number of pubs, cafés and restaurants where refreshments may be obtained.

Oakham is around 25 miles east of Leicester and is well signposted from the A606.

46. Uppingham and Its School

Uppingham School was founded in 1584 by Robert Johnson, the Archdeacon of Leicester who also established Oakham School in the same year. The original schoolroom in Uppingham churchyard is still owned by the school and is a Grade I listed building. It was originally a typical small-town Tudor grammar school where the teaching focussed on Latin grammar, religious education, arithmetic and occasionally history and Greek. It changed little over the years but was transformed by Edward Thring, the great Victorian educator who became headmaster in 1853.

The school that he inherited had only two masters and around thirty boys. In the space of just thirty years he rebuilt the school, creating not only improved boarding accommodation for the boys but also a chapel, laboratory, workshops, a museum and a gymnasium. In academic matters he ensured that the boys studied not only the classics but also mathematics, modern languages, music and practical subjects. He also believed that the development of character was as important as the development of intellect. He had a huge influence on the development of public school education and went on to found the Headmasters Conference. The buildings he created still form the physical core of the school. The school itself is private property but many of the Victorian school buildings are clearly visible around the town. Perhaps the most impressive is the tower and porter's lodge on High Street.

But there is more to see in Uppingham than just the school. The parish church of St Peter and St Paul dates from the fourteenth century although much of it was rebuilt in the Victorian Gothic style in 1860–61. The nearby market square contains a number of interesting historic buildings and is dominated by the Falcon inn which

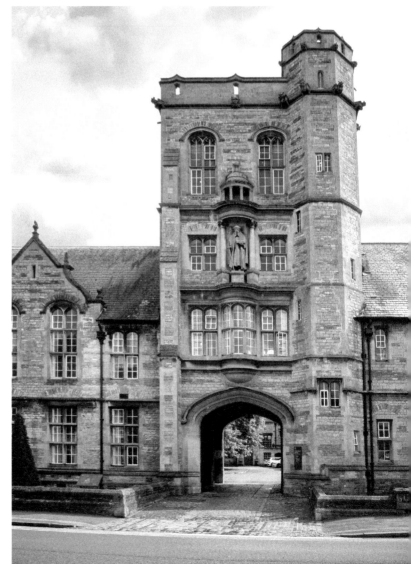

Uppingham School.

dates from the sixteenth century. Elsewhere in this small town the visitor will find a wide range variety of shops, restaurants and tearooms. An informative town trail is available free from local shops.

Uppingham lies just off the A47 between Leicester and Peterborough, around 6 miles from Oakham

47. Lyddington Bede House

Hidden away in the tiny village of Lyddington, the Bede House dates from the fourteenth century and was originally one wing of a rural palace belonging to the rich and powerful Bishops of Lincoln. They came here to enjoy the hunting, but as it was located close to the centre of the diocese it also became an important centre of ecclesiastical administration. The original structure was built on the orders of Bishop Burghersh. It was a substantial and stately building comprising a number of rooms including a hall, great chamber and presence chamber where the bishop held court and greeted important visitors. A private chapel was provided where the bishop and his attendants were able to attend Mass. There was a magnificent formal garden and the bishops also created deer parks, pastures, orchards and fish ponds to provide food for themselves and their retinue. All this changed with the Reformation. The house was seized by the king's commissioners in 1547 and it became a private dwelling. It later passed into the hands of William Cecil, Lord Burley. It was his son, Thomas, who founded an almshouse there called the Jesus Hospital. It seems likely that some major restructuring work took place at this time with much of the original palace being demolished. In a document dated 1601 provision was made for twelve poor men, two poor women and a warden. They were provided with blue gowns and black caps and received a stipend of two shillings and four pence as well as an allowance of pit coal and wood for fuel. In return they were expected to undertake

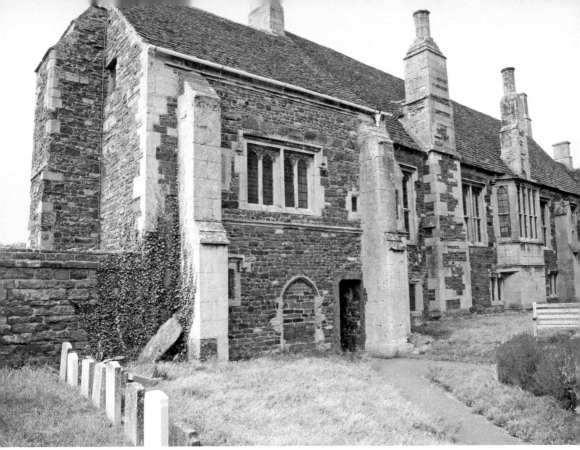

Above: Lyddington Bede House.

Right: St Andrew's Church, Lyddington.

some useful handicraft work and attend religious services on a regular basis. The organisation and administration of the house changed considerably over the years but the building remained an almshouse until the 1930s.

Lyddington Bede House is in the care of English Heritage and is open on a regular basis. One of the rooms has been reconstructed as it might have been in the nineteenth century. In addition to the Bede House the adjacent Church of St Andrew is also of interest. This too dates from the fourteenth century and contains a medieval wall painting which was uncovered in 1937. This is believed to depict King Edward the Confessor dressed in an ermine cloak and holding an orb.

Lyddington Bede House is on Bluecoat Lane, Lyddington, LE15 9LZ. Full details of admission charges and opening times may be found on www.english heritage.org. uk/daysout/properties/lyddington-bede-house

48. Rocks by Rail

Rocks by Rail Living Ironstone Museum was previously known as Rutland Railway Museum. It has been described as a gem for railway and history enthusiasts and aims to preserve and operate industrial locomotives and mineral wagons as well as a wide range of related artefacts. The museum site covers an area of around 19 acres and depicts a typical quarry system when both steam and diesel were widely used. The museum is home to over twenty steam and diesel locomotives in varying stages of restoration. These include two locomotives built

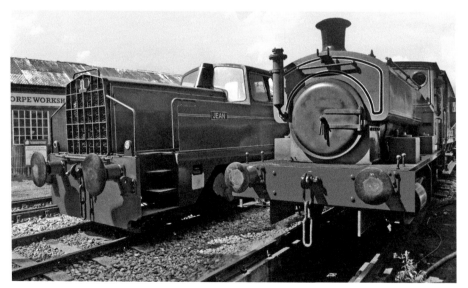

Steam and diesel locomotives at Rocks by Rail. (Courtesy of Rocks by Rail Living Ironstone Museum)

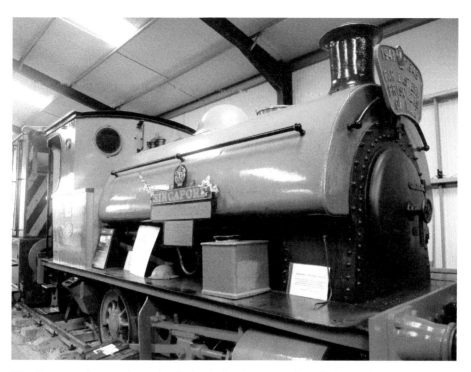

The *Singapore* locomotive at Rocks by Rail. (Courtesy of Rocks by Rail Living Ironstone Museum)

by the Andrew Barclay company which are used to provide rides for passengers on open days. On these occasions, visitors travel on one of three authentic brake vans. On some occasions these trains are hauled by diesel locomotives with names such as *Betty* and *Jean*. Probably the most interesting and popular exhibit is the steam saddle tank locomotive named *Singapore*. This was constructed in the Tyneside works of Hawthorn Leslie & Co. in 1936 and was delivered new to the Royal Navy dockyard in Singapore. It was captured by the Japanese when the base fell in 1942 and the shrapnel damage it sustained is still evident. After the end of the Second World War it returned to Britain where it was put to work at the Chatham dockyards in Kent. After being retired from service it was eventually acquired by the museum and became the first working locomotive in the collection. It is supported by the Far East Prisoners of War Association and is a registered war memorial.

There is much to see and do at Rocks by Rail. As well as enjoying a train ride, visitors can explore the Simon Layfield Exhibition Centre where many of the locos and rolling stock are stored. On 'Driver for a Fiver' days, held on certain Sundays during the summer, visitors get the chance (under supervision) to take a diesel locomotive for a trip down the line and back to the platform.

For details of opening times and the availability of some activities it is advisable to check details on the museum's website: www.rocks-by-rail.org. The Rocks by Rail Living Ironstone Museum is on Ashwell Road, Cottesmore, Oakham, Rutland, LE15 7FF.

49. Halliday's Folly

Halliday's Folly in Greetham is the former home of a stonemason that was given its nickname by local people over a century and a half ago. It was built in 1850 by Thomas Charity Halliday whose stonemason's business was involved in the repair and restoration of churches throughout the area. He was a man who might be accused of bringing his work home with him, for he was in the habit of returning to Greetham with fragments of medieval masonry which he used to decorate his workshop and thus advertise his business. Today this might be regarded as architectural salvage! The building has now been converted into a pair of interconnected holiday cottages which can be rented out by visitors to the area.

Greetham also boasts other interesting and historic buildings including the church, an eighteenth-century inn (the Wheatsheaf) and a rather unusual well.

Halliday's Folly, Greetham.

The ancient well on Church Street, Greetham.

St Mary's Church is a Grade I listed building which still retains some of its Saxon and Norman features. The tower was built in the thirteenth century and the spire was added 100 years later. A modern stained-glass window dating from 1948 depicts the adoration of the magi. Not far from the church is an ancient well which bears the following inscription: 'All ye who hither come to drink/Rest not your thoughts below/remember Jacob's Well and think/Whence living waters flow.' The Wheatsheaf was previously a farmhouse and is a Grade II listed building.

Halliday's Folly is on Great Lane, Greetham. The village of Greetham is on the B668 between Oakham and the A1.

50. Steeple Chasing!

Nikolaus Pevsner in his *Buildings of England* series declared that church steeples were one of the prides of Rutland. He described those at Oakham, Langham, Empingham and Ketton as some of the most spectacular. In addition to their spires many of these churches have other features of interest and are well worth a visit. All Saints' Church at Oakham has a fourteenth-century tower and a needle spire, 162 feet high. One of its glories are the intricately carved capitals that adorn the columns

St Peter's Church, Empingham.

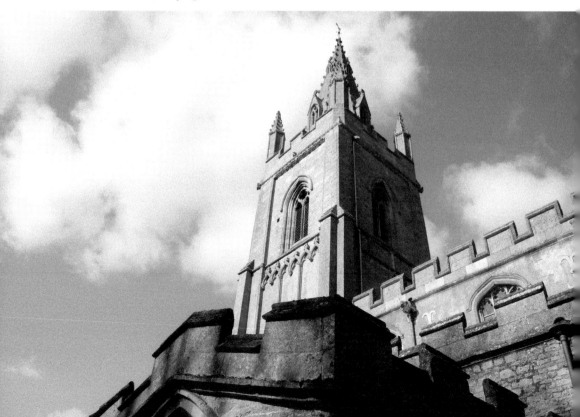

in the nave. These depict a number of scenes from the Bible as well as angels, birds, a dragon, a fox and an ape. The observant visitor will also be able to spot the figure of a Green Man, an ancient fertility symbol. Elsewhere in the church is a Norman font, Victorian stained-glass windows and some fine ceilings. The exterior is richly adorned with gargoyles and grotesques.

The parish church of St Peter at Empingham dates mainly from the thirteenth century although the tower and spire were added a century later. An unusual feature can be seen on the north side of the exterior: the carved figure of a sheel-na-gar. This is another pagan fertility symbol and is quite unusual. Only one other is known in Leicestershire or Rutland. This is perhaps not surprising as the Victorians disapproved of the explicit sexuality of these figures and many were destroyed!

The village of Langham and its church has an interesting place in the history of England. Simon de Langham, who was born here around 1310, rose from humble beginnings to become Treasurer of England, Bishop of Ely, Chancellor of England, Archbishop of Canterbury and a Cardinal at the Papal Court of Avignon. It has been suggested that Simon's patronage may have contributed to St Peter and St Paul being one of the largest churches in Rutland. An alternative explanation is that the parish was home to wealthy wool merchants who may have contributed to its construction and adornment. There is certainly much for the visitor to see, both within and outside the church. In addition to some interesting stone carvings the church also has an early medieval font and a sixteenth-century parish chest. This was equipped with three locks so that it could only be opened by the priest and two churchwardens.

The church at Ketton is dedicated to St Mary the Virgin. Much of the building dates from the thirteenth century but the external stonework around the outside of the West Door is an outstanding example of the late Norman and early Gothic style of architecture. The tower also dates from around this time. Within the tower is a bell chamber containing six bells, the oldest of which dates back to 1598. Perhaps the most interesting features within the church are the benches. These incorporate a number of fifteenth-century carvings known as poppy heads. They depict a fascinating and partly symbolic range of figures which include a pelican pecking at its breast, an angel, a monk, what appears to be a knight and two examples of a 'Green Man'.

All four churches can easily be visited in an afternoon and the villages are all well signposted. A good starting point is All Saints' Church at Oakham. This is in the centre of the town in Church Street, Oakham, LE15 6AA.

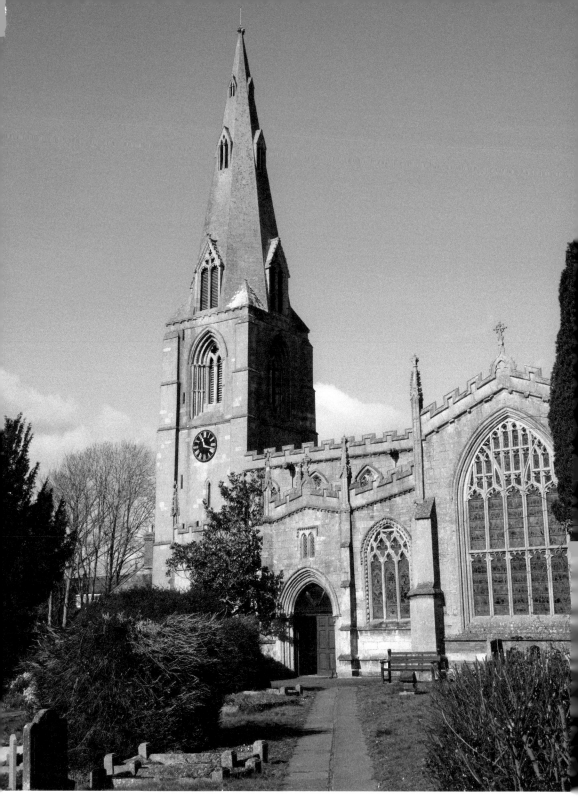

The Church of St Peter and St Paul, Langham.

Acknowledgements

Several people and organisations have helped me in my research for this book. I should like to express my particular gratitude to the following: Jane Cornelius for introducing me to some of the gems and for acting as my guide and chauffeur; Nick Smith for advice and assistance with digital photography; the staff at Nottingham University Library, without whom the research could not have been completed; and the staff at Amberley Publishing for their encouragement and support.

I am indebted to the following individuals and organisations for providing photographs for inclusion in this book: Leicestershire County Council Museums Service, the King Richard III Visitor Centre, and Bill Pemberton (The Glenfield Tunnel).

I am also most grateful to the following for allowing me to use photographs taken on their property: Belvoir Castle; the Century Theatre, Coalville; East Midlands Aeropark; the Revd Mary Gregory, Saint Mary and Saint Hardulph's Church, Breedon; Rocks by Rail Living Ironstone Museum; and Wigston Framework Knitters Museum.

About the Author

Michael Smith has a long and close association with Leicestershire. He was for many years Vice Principal of Castle Donington College and now lives in Ashby de la Zouch where he is Secretary of the History Society. A successful author with ten previous books to his credit, he is also a popular after-dinner speaker. He has also worked as a lecturer in local history for the WEA, Nottingham University and Leicestershire Adult Education Service.